Light on the Landscape

Norman Battershill

with illustrations by the author

Pitman, London
Watson-Guptill Publications, New York

PITMAN PUBLISHING LIMITED
39 Parker Street, London WC2B 5PB

Associated Companies
Copp Clark Limited, Toronto
Pitman Publishing Co. SA (Pty) Ltd, Johannesburg
Pitman Publishing New Zealand Ltd, Wellington
Pitman Publishing Pty Ltd, Melbourne

WATSON-GUPTILL PUBLICATIONS,
A division of Billboard Publications, Inc.,
1515 Broadway, New York, N.Y. 10036, USA.

First published in Great Britain 1977
Published simultaneously in the USA

© Norman Battershill 1977

British Library CIP Data
Battershill, Norman
 Light on the Landscape.
 1. Landscape painting—Technique 2. Light in art.
 I. Title
 751 ND1342
 UK ISBN 0–273–00116–7

Printed by photolithography and bound in Great Britain
at The Pitman Press, Bath

Contents

Acknowledgements

This book is developed from a series of articles written for *The Artist*, and I am grateful for permission to use some of the colour and black and white plates. My thanks also to the numerous owners of paintings which are used to illustrate the book. A. J. Rowell, ARPS, of Hove, Sussex, has my sincere thanks for his skill and patience in taking many of the colour and black and white photographs.

1 Introduction

Painting is much easier in the studio, but the landscape painter must at the least begin his studies outdoors. Working direct from nature imposes limitations of changing light, unsettled weather and, occasionally, discomfort, but whatever the disadvantages the experience of being close to nature is satisfying and exhilarating. There are no short cuts in painting, no instant magic formulae by which the painter will be enabled to represent the elusive qualities of space and light. The only way to become aware of the different moods and atmosphere of the landscape is by constant observation and hard work outdoors. It is not easy to paint light. Fleeting and elusive, it has tried the patience of countless painters. There are changes of light on the landscape almost every minute of the day, from the obvious pageantry of storm and sunset to the polished pewter of an overcast sky or fragmented reflections in a puddle. Some years ago, realizing that the only positive way to study light and atmosphere is to get close to it, I decided to do better than the occasional direct sketch or painting. Since then I have painted and drawn outdoors almost every day throughout the year, regardless of weather, and I feel that the experience is of immeasurable value.

Expressing atmosphere in a painting means more than recording an effect. It is also an attempt to capture some-

thing of the spirit of space and light. The landscape painter learns by experience that light and atmosphere are inseparable. The two painters who above all have understood and captured this spirit are Turner and Constable. Turner's dedication to the interpretation of light and swirling space was monumental. Constable confined his work to the effect of light on foliage, field and water. The novice landscape painter could not do better than to study their work and to be guided by some words written by Constable more than a century ago: 'The landscape painter must walk in the fields with a humble mind, no arrogant man was ever permitted to see Nature in all her beauty.'

The intention of this book is to convey to the student the essentials of the technique of landscape painting, and how to tackle light and atmosphere outdoors and in the studio.

There are sections concerned with the principles of picture making, composition, atmospheric colour, tone and the basic rules of perspective. There is advice on what particularly to look for when painting outdoors, how to start and when to finish. I will be discussing the various media best suited to outdoor sketches and painting and, for the beginner, I shall describe materials and equipment.

A separate section is devoted to the very important sub-

ject of painting and drawing clouds and skies. You will find advice and demonstrations of how to paint reflections and light on still and moving water, and the effect of light on different surfaces, such as roads, tracks, fields and foliage. Also discussed are ways of working from sketches with maximum results. There are demonstration paintings illustrating my approach to making a picture and some exercises to help you progress. There is advice on ways of becoming more observant to the moods of nature.

An everyday awareness of the infinite variation of light forms perhaps the most important part of the landscape painter's life. How it is expressed is dependent not only upon his technical ability but on his quality of thought. It is my hope that this book will increase your desire to understand and appreciate the joy of nature through a painter's eyes.

2 Media, materials and equipment

Oil colours

Oil colours offer the widest scope of expression to the landscape painter: their characteristic depth, richness and strength make oils the ideal medium for painting the effects of nature; and they are equally suitable for small sketches and very large works.

The technicalities of oil painting are more complex than those of any other medium. There is certainly not room to go into them here, and there are several excellent books on the subject. What follows is a basic list of materials you will need to begin painting with oils.

Brushes
Always start off with the best brushes you can afford. A few good quality brushes will serve you better than a dozen cheap ones. As you progress you can add more and build up a stock.

The most frequently used brushes for oils are made of hog bristles. Long-hair brushes are preferable, because short-hair brushes tend to collect paint in the ferrule, which may cause difficulty for a beginner. The brushes may be tapered or square- or round-ended, the square-ended brush giving a positive brushmark, the rounded one a softer effect. The choice is a matter of personal style

and preference. A set of four bristle brushes, say numbers 2, 3, 5 and 7, together with a pointed sable for fine work, will meet most of your needs to begin with. Avoid using small brushes unnecessarily and in particular avoid small sables if your work is too tight: a good quality hog hair brush is capable of a narrow and interesting line.

Always wash your brushes at the end of a painting session. First clean them with white spirit (mineral spirits), or turpentine, then wash them with household soap and warm water and rinse thoroughly. While the bristles are still damp re-shape them between finger and thumb so that they dry in the correct shape. Then lay them horizontally to dry (if a brush is left standing up to dry the water will run into the ferrule and may decay the metal and the roots of the hair). Paint sediment tends to sink to the bottom of the jar containing the turpentine, but if

you allow it to settle for a few weeks it will be possible to pour off the fluid into a clean jar for re-use.

It will be easier to keep light colours fresh and clean if you have separate brushes for clouds and sky.

Supports

Artists' quality canvas of a good pure flax is expensive, but a delight to paint on. Canvas is available in various grains from open weave prominent grain to a very close weave. It can be bought by the yard primed or unprimed, or ready prepared on standard size stretcher frames. When buying primed canvas by the yard, roll a corner between the fingers. The canvas should be pliable and the primer should not crack. Stretcher frames can be bought without canvas, and the stock lengths of stretcher pieces allow a variety of frame sizes. Stretching canvas is not a difficult job if you use canvas-straining pliers (stretcher pliers) which help to get the canvas taut. For directions, see below.

Oil painting paper and blocks and boards of fine, medium or coarse grain are all good supports which are considerably cheaper than canvas. Cheaper still, and quite effective, are watercolour paper, or a loosely woven cotton like scrim, butter muslin, hessian (burlap) and even brown paper. Hardboard (Masonite) is an economical, rigid support, and the offcuts are particularly useful for small sketches. The rough side is too mechanical to be interest-

Stream. 9 June 76

ing, but the smooth side can be very satisfactory, though the surface does not suit every painter. It will, however, have to be primed before use.

Priming First lightly rub the surface of the hardboard with medium sandpaper, to provide a key or slight texture. Dust off and apply two thin coats of diluted primer, taking care that the brush strokes are not too evident. Good quality household paint is a cheap alternative to artists' quality primer, but durability and compatibility cannot always be guaranteed. The advantage of using an acrylic gesso or emulsion primer is speed of drying, and they are very suitable for surfaces such as hardboard (Masonite), but they are not to be recommended for priming canvases on stretchers, except possibly for very small ones. The traditional method of sizing and priming with white lead takes much longer to dry. It is a good plan to build up a stock of primed canvases to allow for drying time.

Staining If the painting ground does not have a preparatory tint the white is often too bright and this affects tone values and colours. It is normal practice to stain the ground with an earth colour. Burnt umber or yellow ochre provides a pleasant ground. Alternatively, a touch of burnt umber mixed with primer gives an opaque shade.

Straining canvas First slot the stretchers together tightly, but don't put in the corner wedges yet. Cut the canvas to about $\frac{3}{4}$ in. (20 mm) larger all round than the stretcher

frame, cutting so that the grain of the canvas runs evenly across. Lay the stretcher flat on the canvas, with the round edge of the stretcher on the outside (this is very important, as otherwise the sharp edge will cut the canvas). Turn up one of the longer sides of the canvas and put a tack half way in. Put in the tack on the opposite side, then repeat on the short sides, applying even tension on all four sides. When this is done, drive home all the tacks. If you are going to prime the canvas, do it now. When the primer has dried, tap in the corner wedges evenly to get a taut surface. Great care must be taken to prevent pressure or knocks to a canvas on a stretcher, particularly from the back.

Palette
The traditional wooden palette is manufactured in a choice of three shapes: oval, kidney or oblong. The oblong is the most convenient for painting outdoors, as it will fit into an oil colour box. The oval and kidney shapes are suitable for the studio. Whichever shape is preferred, it is most important that the palette should be well balanced. A new wooden palette needs a rub over on both sides with a little linseed oil. This will help prevent the paint from sinking into the wood.

Paper tear-off palettes (they usually come in pads of about fifty leaves) have the advantage of convenience, especially for outdoor painting. A plastic palette is light-weight, rigid and durable. It is easy to clean paint off glass, and for studio work I often use a clear plate glass door, with the edges smoothed down, which I took from an old kitchen cabinet. A sheet of clean white paper underneath gives a good background for mixing colours.

Medium
Oil colours have an improved flow when used with a mixture of pure turpentine and artists' quality linseed oil. The addition of a little varnish will reduce drying time. There are also excellent manufacturers' mediums on the market.

However, don't overdo the quantity of medium, as using too much in proportion to paint may cause cracking later. Some painters prefer not to use any medium at all.

Turpentine

Turpentine is the usual diluent for oil colours. It needs to be used with care, as if too much turpentine is mixed with the paint it may break down the oil colour binder, which will make the paint powdery and dull.

White spirit – turpentine substitute (mineral spirits)

Used as a diluent for oil colours and also for cleaning brushes (it is quite unnecessary to use the much more expensive, highly refined turpentine for cleaning brushes).

Dippers (palette cups)

Metal cups to clip on to the palette to hold oil and medium during painting. The deeper type of dipper is much more convenient than the shallow one.

Road liable to flood. Oil on hardboard 30 × 24 in./762 × 610 mm. The title for this studio painting was taken from a notice warning motorists 'Road liable to flood'. Raised above the road by several feet, the gangplank allows pedestrians safe passage. Although the road turns out of the picture interest is contained by the vertical posts and the band of dark hedge. The two distant trees almost obliterated by mist balance the composition. The effect I wanted to achieve was the atmosphere of filtered light from misty grey clouds.

Varnish

Varnish protects the surface of a painting and enriches the colours, but the picture should be allowed to dry for at least six months before the final varnish is applied. If it is done too early the difference in the drying activities (expansion and shrinking) between the varnish and oil films may cause cracking. For the temporary protection of recently executed oil paintings and for re-touching dull areas during painting, re-touching varnish may be used.

Alkyds

Instead of the traditional base of linseed oil normally used in artists' oil colours, alkyd resins take its place. Alkyds are similar to oils but with the advantage of drying quicker, thus facilitating early application of oil colour techniques, such as scumbling, glazing and varnishing.

Watercolours

The beauty of watercolour lies in its freshness and transparency. These characteristics make it particularly well suited to interpreting the effects of light and atmosphere. They also make it one of the most difficult of all media to handle, as overworking will quickly destroy its charm.

The watercolour painter can work in either the direct or the controlled wash technique. If he is using the direct method he will paint on to dry paper without any preparatory washes of colour. This enables the painter to be entirely concerned with the effect of light and atmosphere from the start. It does, however, require courage and a knowledge of tone values. The controlled wash technique is particularly well suited to mist and atmospheric effects. A wash is applied all over the paper and while it is wet further colours are dropped in. Parts can be taken out with a sponge or a brush. When this atmospheric lay-in is dry, forms and stronger colours are added to complete the painting.

Brushes

Brushes used for watercolour are usually made of soft hair,

the best and most expensive being pure red sable. Cheaper
substitutes are available, but again, a good brush is a worth-
while investment. Trying to paint with a cheap, inferior
brush leads to nothing but frustration.

A watercolour brush must be capable of laying broad
washes and also of giving a thin line. When you are buying
a brush test it by dipping it in water. When the excess
water is shaken off it should come naturally to a point. I
would suggest you start off with a number 4 and a number
8, and add the sizes in between as you go along. A water-
colour mop brush is good for large sky washes, though
some painters substitute an old shaving brush to great
effect. A small sable is useful for detailed work, but you
may find it unnecessary: a good large brush has a suffi-
ciently fine point to cope with most detail.

Always wash your brushes thoroughly and rinse in clean
water. Then bring the hairs carefully to a point and lay the
brushes horizontally until they are dry.

Supports
The most commonly used supports are watercolour paper
and watercolour boards. Boards are pleasant to work with

but more expensive than paper and they do have a tendency to warp with excessive moisture.

The grading of paper is measured by the weight of the ream, or the weight in grammes per square metre. The range available is from 40 lb (110 gsm) to 400 lb (850 gsm) but 72 lb (150 gsm) is about the lightest in general use, and 240 lb (535 gsm) the heaviest. A good intermediate weight is 140 lb (295 gsm). Papers lighter than this will require stretching before use, to avoid the danger of buckling. Patent watercolour stretching frames are available from art suppliers, but it is quite easy to stretch paper without a frame.

Stretching paper First soak the paper thoroughly, immersing it in clean water. Drain off the surplus water and lay the paper flat on a board not less than $\frac{3}{8}$ in. (10 mm) thick and 2 in. (51 mm) wider all round than the paper. Stick down the edges of the paper with brown paper gummed tape. It will dry out taut and flat.

Some papers have a heavy coating of gelatine size which makes it difficult to apply watercolour, but if necessary soaking in clean water will remove this.

Both watercolour paper and watercolour board are available in a choice of three surfaces.

Hot Pressed: a smooth surface more suitable for drawing than for broad colour washes.

Not (in the US known as Cold Pressed): a semi-rough paper, ideal for texture effects and yet not too rough for fine drawing with a brush.

Rough: coarse surface. In experienced hands this paper can be used most effectively for depicting the effect of sparkling light on fields and water. I would not recommend it to a beginner as the rough tooth needs expert handling if excessive granulation of colour is to be avoided. However, my advice is not intended to be accepted without question. There is no reason why you should not paint on either a very rough or a very smooth surface if you want. Learn by practical experience and keep your experiments on different weights and surfaces for reference.

The usual method of presenting watercolours is mounted (matted). If you wish to do your own mounting, remember that while stout paper can be fixed to the mount

all round, thin paper should be fixed at the top only, as it could be buckled by the different rates of expansion and contraction in changing temperatures.

Always store paper flat, in a dry place.

Tinted papers In the hands of an experienced painter tinted paper, as it gives a background tone, enables an effect to be achieved more quickly than with white paper. This makes it particularly useful for outdoor work, where time is always at a premium. Pale greys especially are a delight to work on, as the grey tone will unify a painting in a very pleasant way. You will see this for yourself if you paint a group of trees in simple masses on white paper and then repeat the experiment on grey paper. However, it is advisable to learn tone values by painting on white paper before using tinted papers extensively.

Sketchbooks and sketch blocks A 140 lb (295 gsm) water-colour paper in a spiral-bound book is ideal for sketching. Thinner paper, though unsuitable for broad washes of watercolour, is adequate for line or small areas of colour: watercolour can be used in small areas on paper as light as 72 lb (150 gsm) without its being stretched, but it does tend to buckle. And be careful – excessive moisture in washes will buckle not only the top sheet of paper but all those underneath as well.

Paintbox

Watercolour pigment is available in tubes and pans (cakes). I myself prefer tubes, as the pigment remains moist and ready to use, while pans can dry out, causing unnecessary wear and tear on the brushes. Pans can however be restored to a workable condition by immersion in warm water, or alternatively by being covered with a clean damp cloth.

A watercolour palette or box must have adequate mixing wells and divisions for colour, and a thumb-hole or ring underneath for ease of holding.

Gouache and poster colour

Gouache is a lovely medium sadly little used for painting these days, though designers' gouache colours are extensively used in design studios throughout the world.

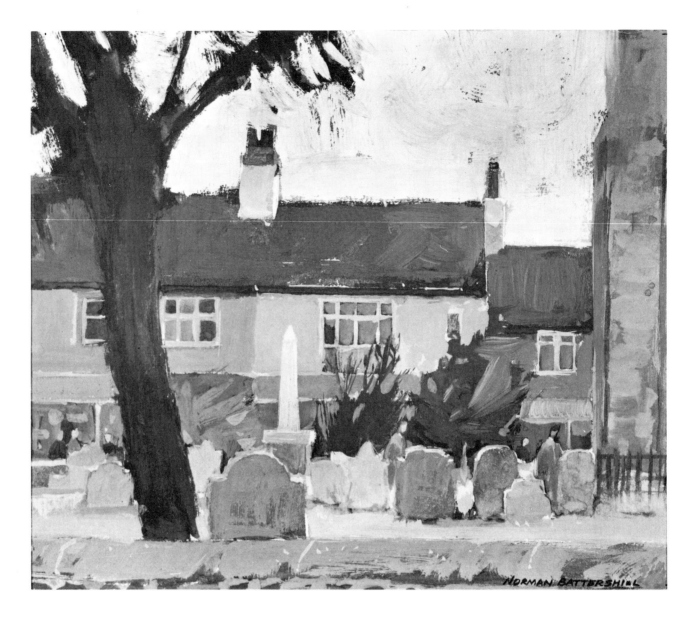

Churchyard, Shoreham-by-Sea.
Gouache on watercolour board
10 × 9 in./254 × 229 mm.
I was particularly interested in the
pattern of the tombstones which
seemed to be repeated in the
windows beyond, and also in the
effect of light on the grass and
tombstones. The obelisk gives an
important vertical emphasis and
moves interest into the middle
distance.
Because gouache dries very
quickly it is easy to overlay one
colour on another. I applied this
technique to the wall in the
foreground and to the ancient
tombstones, to suggest texture.

Strictly, the term gouache refers to an opaque water-
colour technique, but gouache colours can also be used
diluted to give a thinner effect. The pigments are those
used in watercolour paints, with the addition of a white
pigment such as precipitated chalk or whiting. The over-
use of white pigment in the mixing must be carefully
avoided as it reduces gouache to a chalky appearance and
the colours lose vitality.

Gouache is thinned with water, and watercolour brushes
are normally used, but interesting and vigorous effects
may be obtained with oil colour brushes. In this case it is
essential to ensure that the brushes are free from oil.

The support used may be paper, card or board. Tinted

MEDIA, MATERIALS AND EQUIPMENT

watercolour paper and pastel paper of a neutral colour are particularly suitable. Priming is not necessary for painting in gouache, but if the support is not coloured a thin wash of acrylic, watercolour or gouache may be applied to the paper or board if you wish to give a coloured background.

Gouache must always be used lightly. Too heavy an application may result in cracking. The finished painting will need protection and must be placed under glass, separated from the glass by a mount (mat).

Poster colour is similar to gouache except for the difference in quality of the pigment. Nonetheless, paintings I did in poster colour many years ago have retained their freshness and strength of colour.

Both gouache and poster paints, if not too thinned, dry slightly faster than watercolour, which is an advantage for outdoor work. Allowance must be made for slight lightening of colour when dry.

Pastel

Pastels are dry chalks made of pigment particles bound together in the form of a stick. They are available in several degrees of hardness from medium hard to very soft. Pastel is a very versatile medium, capable of a strength and density approximating to that of oils, or the delicacy of watercolour. This versatility, together with the convenience of a dry medium for outdoor work and the choice offered by the enormous range of ready-mixed colours, makes pastel excellently suited for landscape painting. Moreover, their reputation for fragility is totally undeserved: on the contrary, given proper care pastel is more permanent than either oils or watercolour. The only disadvantage is the danger of smudging, but this can be overcome with a bit of attention, and if a picture does become rubbed it is an easy matter to reinstate the damaged area.

Supports
Pastel can be applied to almost any oil-free surface providing it has a texture suitable for the adhesion of the pastel. Smooth paper will not hold soft pastel well, but it may be used for drawing with hard pastel.

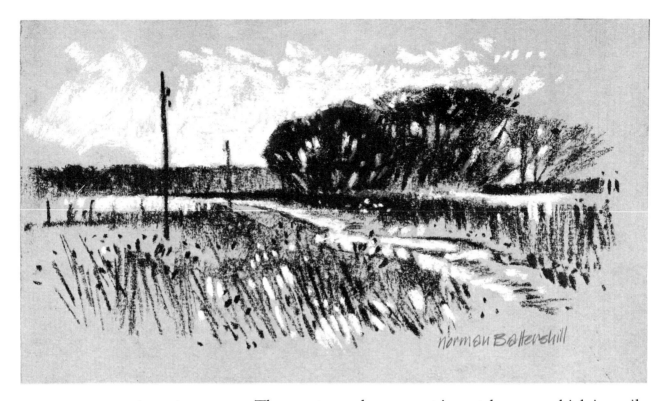

Fields at Steyning. Soft pastel on grey scrapbook paper 8½ × 4½ in./216 × 115 mm. One dark and one light pastel were used for this sketch, to illustrate the range of tone obtainable by varying pressure. Grey paper provides an additional tone. This combination is very useful for rapid tonal work, particularly outdoors. Establish the dark tones first.

The most popular support is pastel paper, which is available in a variety of surfaces, colours and thicknesses. The colour of the paper is often used as an additional tone. The most common colour is a neutral medium grey, and the brightly coloured papers and fancy surfaces such as flock paper are really better avoided by the inexperienced. Buckling may be a problem with the thinner pastel papers, but this can be overcome by mounting the paper on cardboard.

Watercolour paper given a wash of gouache or watercolour is also an excellent ground for pastel. But personally I use almost any kind of paper to experiment with – a cheap sketch pad will often provide a very satisfactory surface.

A particularly interesting surface is offered by hardboard (Masonite) primed with emulsion or acrylic paint into which pumice powder or marble dust has been sprinkled.

Cleaning To clean pastel sticks put them in a container with a lid, cover them with flour or ground rice and shake the container. This will remove the dirt and dust from the pieces, restoring them to a clean condition.

Care Reasonable care in storing and handling should remove the risk of smudging. Pastel paintings must be

Another example of dark and light pastels used on a tinted ground.

Distant village. Pastel on paper 12 × 8 in./305 × 203 mm. The grain of the paper (from a cheap sketchbook) is used to suggest atmosphere and texture.

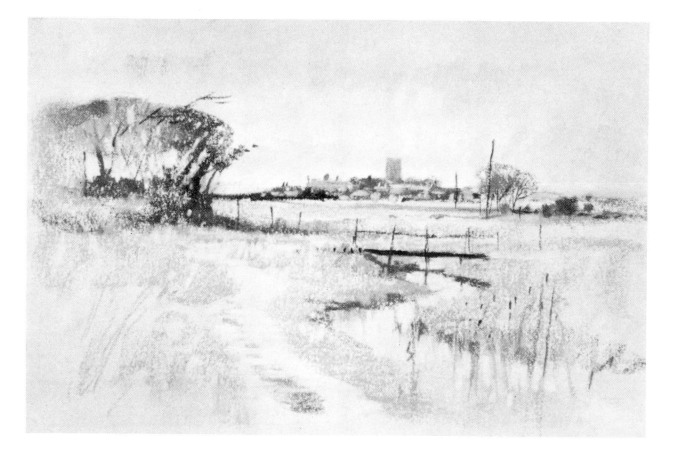

kept in a dry, dust-free atmosphere. The safest place is in a frame behind glass. Where this is not possible they should be laid flat with sheets of paper (I use discarded cardboard mounts or mats, but even newspaper will do) laid between the paintings and fastened at the corners with paper clips. Loose particles and pastel dust can be removed from the surface of a pastel painting if the edges are jolted. The use of a fixative will prevent this, but fixative does slightly darken the pastel, and it will not be necessary if the painting is put behind glass immediately.

Pastel sketchbooks must be securely held together with a strong rubber band or spring clips to prevent rubbing. Alternatively, apply a fixative as soon as you finish the pastel.

If you have the room to spare, a drawing office plan chest or flat file is a very useful piece of equipment for storage. They can be bought second hand. I store all my pastel paintings, sketches, boards and paper in a six-drawer plan chest. However, if you can't afford the space two sheets of 30 × 30 in. (762 × 762 mm) hardboard will make a suitable storage folio. Glue binding or a piece of cloth tape to the long edge inside and outside to form a hinge.

Pastel paintings can be safely transported packed between two panels if the panels are firmly held together.

Mounting (Matting) A mount must be thick enough to keep the surface of the pastel painting away from the glass. For this reason a double mount is often used. Picture framers will sometimes, for a charge, dry-mount pastel paper to mounting or backing board. There is always the risk, however, that the textured surface may be ironed out, as it is a heat process.

If you prefer not to use a mount the pastel can be separated from the picture glass with wooden strips around the edges inside the frame. I use square section balsa wood, which is available in lengths from model shops. Alternatively, cardboard strips can be built up in layers to serve the same purpose.

A painting on hardboard larger than 36 × 24 in. (914 × 610 mm) will need batten supports or light wood strips all round and across the width. Fix with impact adhesive or contact cement and keep the nails to the outer edge so

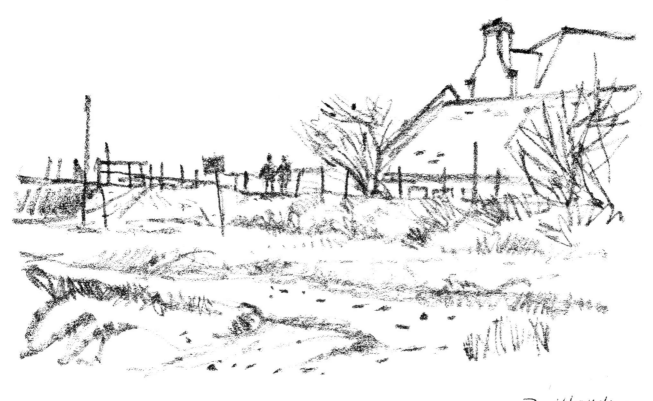

3 illarch 3
10 a.m.

that the frame will conceal them. Battening must of course be done before painting. For paintings of this size I use a 3 in. (76 mm) width oil painting frame, which is stable and gives support to the pastel painting and glass.

Low tide, Shoreham. (Above) Oil pastel on paper 14 × 8 in./ 356 × 203 mm.

Oil pastels

Oil pastels have the great advantage of being resistant to smudging. Like dry pastels they are effective on the poorest quality paper – I use very cheap scrap paper, generally in a pleasing grey or cream. Oil pastels are ideal for rapid sketches.

Acrylics

Acrylic paints are artists' quality colours using an acrylic polymer emulsion as a binder. They are diluted with water. They are extremely versatile and their particular advantage is that they offer an exciting range of techniques from heavy impasto to delicate transparent watercolour-

style washes. Like most water-thinned paints they dry rapidly, but unlike watercolours they harden to a film which is resistant to water. This can be a disadvantage, but on the other hand the quick drying does enable rapid progress to be made on a painting: it is generally possible to paint over the underpainting within a few minutes.

Brushes

Either oil or watercolour brushes can be used for acrylic, but nylon brushes hold acrylic paint particularly well. These do have a tendency to broaden and lose shape, but when they have become unsuitable for painting they can be used for varnishing. Four or five nylon brushes are enough to begin with, say a range from $\frac{3}{8}$ in. (10 mm) to 1 in. (25 mm). Oil colour brushes are effective when a more textured effect is required. Sable watercolour brushes may safely be used for the watercolour technique, but the opaque technique, where very little water is used, seems to wear them out. It is essential that the paint should not be allowed to dry and harden in the brush.

Supports

Acrylic paint can be used on almost any surface, flexible or rigid, so long as it is quite free from grease or oil.

Near Steyning. Diluted acrylic on grey paper 9½ × 5 in./ 242 × 127 mm.
I used grey scrap paper for this watercolour-style outdoor acrylic painting, applying the paint to the dry paper with very little wet-in-wet blending. Being thin and of poor quality the paper would not take a wash.
The colours I used were sap green, ultramarine and burnt umber, no white. The grey ground gives a middle tone.

Plate 1 *Church and meadows.* Watercolour on watercolour board
6 × 4 in./152 × 102 mm. Watercolour is at its best when applied direct
without overworking.

Plate 2 *Fishing shack, Cornwall*. Alkyds on hardboard 24 × 20 in./
610 × 508 mm. A studio painting. The scene is imaginary but typical of
the fishing coves that abound in Cornwall.
The darkest parts are placed well within the picture area to focus
interest. A few planes often have more impact than finely graded
recession. The colours I used were ultramarine, cadmium red, yellow
ochre, cadmium yellow, burnt sienna and titanium white.

Plate 3 *October morning*. Oil on illustration board 10 × 7 in./254 ×
178 mm. A pochade painting done outdoors on a cold October
morning. Winter is an exciting time: colours are rich and tone values
very strong. I used a medium of half turps and half linseed oil.
Foreground interest is pronounced, so I gave prominence to the shrub,
fence and tree to give a better balance.

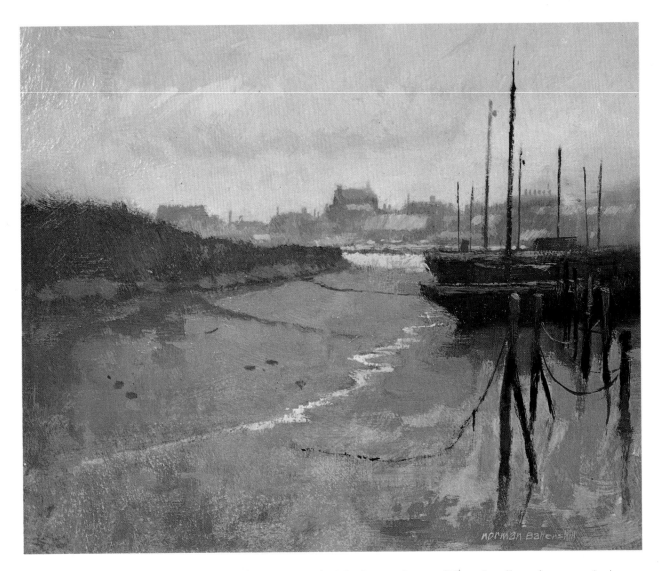

Plate 4 *Low tide, Newhaven, Sussex.* Oil on hardboard 12 × 10 in./
305 × 254 mm. The effect I was after in this painting was a soft
atmospheric light from an overcast sky. Tonal contrasts required careful
consideration to give unity. The colours I used were ultramarine, burnt
sienna, yellow ochre and burnt umber.
To further the effect of stillness and quiet I used minimal colours and
low tones.

The smooth side of hardboard (Masonite) is a particularly good surface for acrylic. It should be lightly rubbed down with sandpaper and two thin coats of acrylic gesso or emulsion applied as a primer.

Oil-primed canvas is not compatible with acrylic paint. Unprimed canvas needs sealing with several thin coats of acrylic primer. There are also simulated canvas boards and canvas primed with acrylic specifically prepared for acrylic paint.

Oil-primed paper is again not suitable as the paint may not adhere. If you are not too concerned with durability, however, this surface may receive acrylic if it is wiped over with a damp cloth and a small amount of washing-up liquid (dish-washing detergent), then rinsed with a clean damp cloth. Watercolour paper is fine, but paper of less than 140 lb (295 gsm) will need to be stretched. It is not

Summer haze. Acrylic on hardboard 22 × 16 in./559 × 406 mm. A simplified subject painted in the studio. The effect of haziness is reinforced by the absence of detail. It was important to lower the tone of the arch of the bridge to prevent its becoming too predominant.

normally necessary to prime paper when painting with acrylic.

Thin cardboard has a tendency to warp with excessive moisture; thick card is more suitable. An application of acrylic medium will seal it, or the board can be primed with acrylic primer. Diluted acrylic medium is particularly effective used on brown cardboard, as it preserves the golden colour and produces a pleasant textured working surface.

Palette

The traditional wooden palette is not suitable for acrylics, as the rapid drying and strong adhesion of the paint makes it difficult to remove from the absorbent surface of the wood. A plastic palette is more practical (plastic offcuts make good cheap palettes). Immersion in warm water makes it easier to remove dried colour with a palette knife. Tear-off disposable paper palettes are very convenient.

Medium

Matt medium For glazing or thinning mix in any proportion with acrylic colours. It will maintain the matt quality of the colours while increasing their translucency. May be thinned with water. Not suitable as a varnish. Not removable.

Gloss medium As with matt medium, for glazing or thinning may be mixed in any proportion with acrylic colours. Will increase gloss and translucency. May be thinned with water. May be applied as a final gloss varnish. Not removable.

Gel medium Retards drying rate and produces thick textures when mixed with the paint.

Varnish

Matt or gloss. For mixing follow manufacturers' instructions. Thinning with water is preferable to applying direct from the bottle.

Acrylic retarder

May be mixed with acrylic paint to slow down the rate of drying.

Water tension breaker
May be added to water to make the thinning of the acrylic easier and more rapid.

Charcoal

Charcoal is a wonderful medium, exciting and expressive in either thin line or tonal masses. It is perfect for capturing the fleeting moments of cloud studies, reflections and the changing light and atmosphere of the landscape. The disadvantage is that charcoal smudges more easily than pastel. The slightest movement or pressure will spoil a charcoal drawing. While you are working hold your wrist well off the paper and either roll your sleeve up or fasten an elastic band round your cuff. If the work is not going immediately under protective glass then it must be fixed with a charcoal fixative. This may be applied with a diffuser or

House at Steyning. Charcoal on paper 16 × 12 in./406 × 305 mm. I began this outdoor sketch somewhere around the middle and worked outwards. Although it is only a sketch the principles of composition and perspective still apply. I did not mark out any vanishing points but relied upon my judgement and eye.

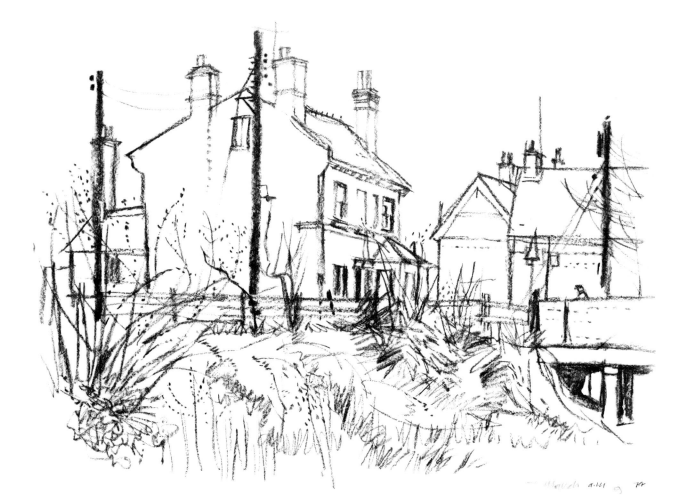

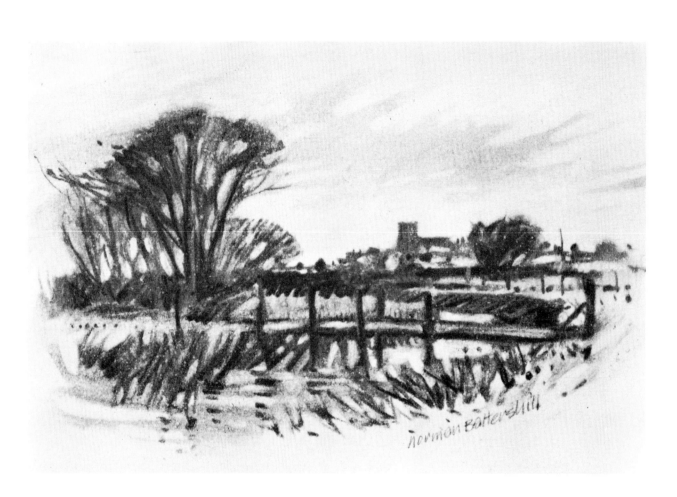

by the more convenient method of an aerosol. Go carefully – several thin applications are the safest way, as too heavy a layer may result in the paper being discoloured.

Charcoal is available in several thicknesses. Thin charcoal needs to be handled very carefully. This fragility, however, may have its use if it helps you to develop a sensitive and light touch in your drawing. Charcoal pencils are easier to use, but I prefer the sticks for their broader style of drawing.

Particularly interesting tones can be obtained if you use a medium grey pastel paper. White chalk can be used with discretion for indicating the lightest tones.

Conté

Conté is a synthetic chalk medium similar in expression to charcoal and like charcoal effective in either linear or broad work. A very useful medium for outdoor work.

Convolvulus. Pencil.
Drawings like these help to develop awareness of nature's patterns and rhythms. Forget that you are copying and look for inside and outside shapes. If the broader medium of charcoal is used the drawing of detail needs to be larger.
These drawings are actual size.

Evening. Charcoal on tracing
paper 7 × 4 in./178 × 102 mm.
An outdoor sketch was the basis
for this studio drawing.

MEDIA, MATERIALS AND EQUIPMENT

Prussia Cove

22 oct

Prussia Cove, Cornwall. Conté on cartridge paper 11 × 8 in./ 279 × 203 mm.
An outdoor drawing in conté on cheap cartridge paper (white drawing paper).
The tree is not bending in a breeze; it has grown that way, forced by strong coastal winds.
I began with the tree, placing it off centre, and then drew in the houses, working round to the foreground.

Pencil

A graphite pencil produces a very wide range of sensitive tones, and although it does not possess the broadness of application of pastel, conté or charcoal it is a lovely and expressive medium. Many of my outdoor drawings are pencil sketches in sketchbooks measuring 5 × 3 in. (127 × 76 mm). They provide an invaluable reference and source of subjects for paintings.

Artists who specialize in pencil drawings may work with half a dozen different grades, from 6H to 8B. Charcoal, conté and carbon pencils are also interesting to try, but mistakes cannot be so easily eradicated using these. Pencil drawings do need care: soft pencil has a tendency to smudge and is not easily reinstated; and heavy pressure results in a shine on the pencilled surface. A putty eraser slightly warmed by kneading between the fingers is best for erasing; it is cleaner and does not leave any bits.

Start with small studies using an HB pencil on paper that

Tin mine, Cornwall. Conté on paper 11 × 8 in./279 × 203 mm. Perched on the edge of a cliff with a several hundred feet drop to the sea below, Towan Roath tin mine shaft is an exciting spectacle.

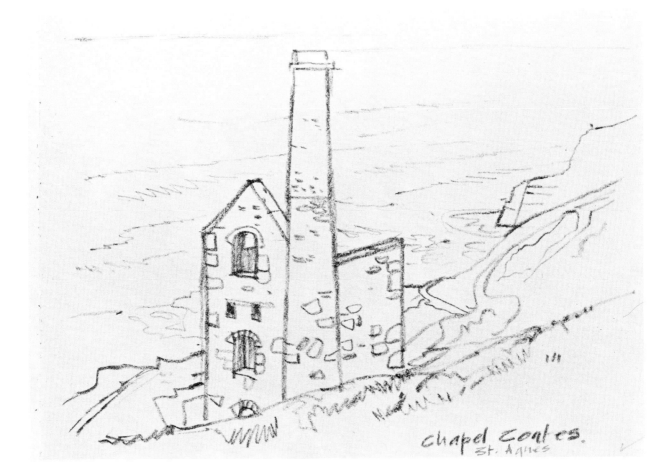

chapel coates.
St. Agnes

takes shading well. You may prefer to begin your drawing with an exploratory outline and then develop it with a firmer line to include detail and shading. Or start at the point of interest and work outwards to completion, without preliminary drawing. Light and shade suggest depth and give the illusion of space and atmosphere. The small, exquisite drawings of Constable are supreme examples of pencil tone.

It is also good practice to draw in line alone. A great number of Turner's sketchbooks consist of linear pencil drawings. Without resorting to tone he was able to represent infinite distance by a wonderfully sensitive line.

Pen and ink

Traditional pen and ink drawing requires a good deal of skill and a disciplined approach. Unfortunately it has fallen out of favour and very few artists use the technique today, but good examples are to be seen in the books of the late nineteenth and early twentieth centuries. A full tonal pen and ink drawing demands infinite patience: each line is a positive statement and any alteration or erasure is likely to be noticeable. Comfortingly, however, when a line drawing is used for reproduction, although the use of retouching white will be visible on the drawing it will not show up in the reproduction.

There is a wide range of nibs available, from the fine mapping pen to the broad script or poster nib.

Soft, absorbent paper is not suitable for pen drawing as the surface pulls up. Ink flows better on a smooth-surfaced paper such as writing or typing paper. If you would like to try pen and ink start with smooth writing paper and a writing pen and restrict the size of your drawing to not more than 6 × 4 in. (152 × 102 mm). Lightly draw in the main shapes and some detail with an HB pencil. Hard pencil pressed too heavily makes an indented line unsuitable for pen and ink drawing. You can then either draw in all the main outlines with ink or begin shading a small area first. Tone can be obtained by hatching. Keep the shading lines open. When the ink is dry the pencil lines should be removed with a softy putty eraser. Avoid over-zealous rub-

Churches at Jevington, Alfriston and Shoreham, Sussex. Pen and ink on illustration board 11 × 8½ in./ 279 × 216 mm.
Formal-style pen and ink drawings commissioned for a series of notelets. The originals were drawn twice the size of the reproductions.

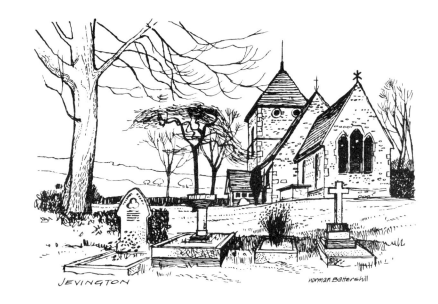

JEVINGTON

norman Battershill

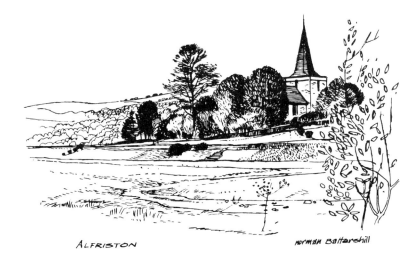

ALFRISTON

norman Battershill

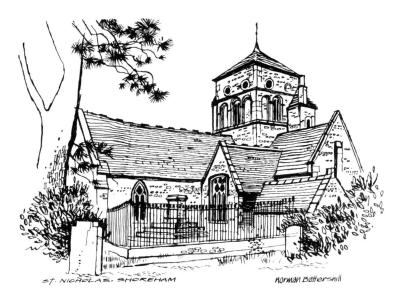

ST. NICHOLAS. SHOREHAM

norman Battershill

MEDIA, MATERIALS AND EQUIPMENT

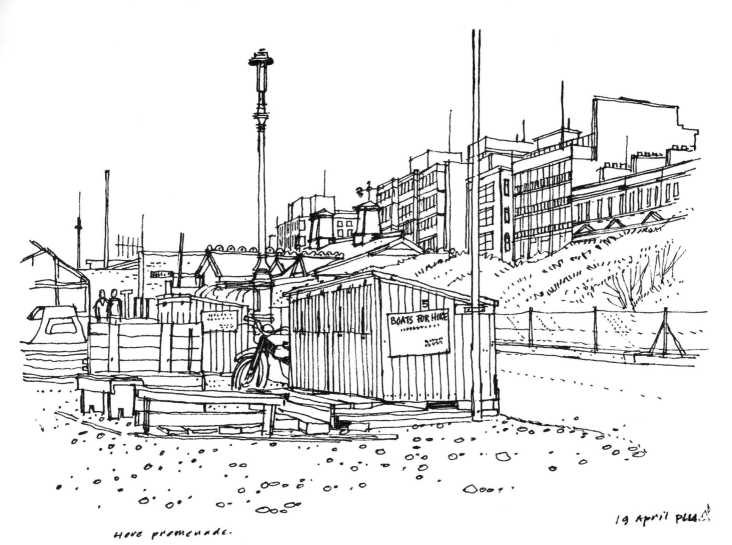

Hove promenade.

19 April plu...

bing, which will fur the ink lines.

Drawing in detail with pen and ink is the slowest of techniques and unlikely to be used outdoors unless the artist has a great deal of time and patience. A quicker method is to draw in ink with the sharpened end of a stick, reed or quill, which also produces an extremely interesting quality and texture of line.

Ballpoint pens and fibre tip pens have largely replaced the traditional steel drawing nib. Both are available in a wide range of colours and are suitable for sketching, though some of the inks in fibre tip pens may fade or change colour.

Brush drawing often has a greater fluidity and range of expression than pen. Laying washes of colour over a dry brush and ink drawing is a technique favoured by some watercolour painters. It is particularly suitable for draw-ings of buildings. Essentially it should be a line drawing

Hove Promenade. Cartridge pen on paper 12 × 8½ in./305 × 216 mm. I began this outdoor sketch by drawing the right-hand pole, and let everything else work into place as I went along, without worrying about trying to fit it all into the page.

with washes of colour. The ink must of course be water-proof, unless you intend the lines to smudge when wetted.

Equipment

Always buy the best materials and equipment you can afford, but remembering that the most costly is not necessarily the best. If you are in doubt don't waste money but seek advice from a professional painter or a local art society.

Easel
The easel is the most expensive single item you will have to buy, and needs careful selection. It should be absolutely functional, the fewer fittings there are to fiddle with the better. Check particularly that it will hold either a canvas *or* a panel. The fault of some metal easels is that the parts easily become detached and get lost, and buying replacements can be difficult, if not impossible.

Outdoor easel Stability, ease of assembly and portability should be the star features of an outdoor easel.

A box easel is ideal for painting outdoors, as bottles, brushes, dippers (palette cups), paints, palette and canvas are all carried in one box. Most boxes allow for carrying one or two wet canvases or boards as well. They are also extremely stable. I have only once had to use a weight to hold my Lefranc box easel down, and that was when I was painting a 30 × 24 in. (762 × 610 mm) canvas on a very windy day on a Cornish beach. The corresponding disadvantage, of course, is the weight: when the box is fully loaded it can be very tiring to carry any distance.

Tripod easels for outdoor painting are available in a

(a)

(b)

(c)

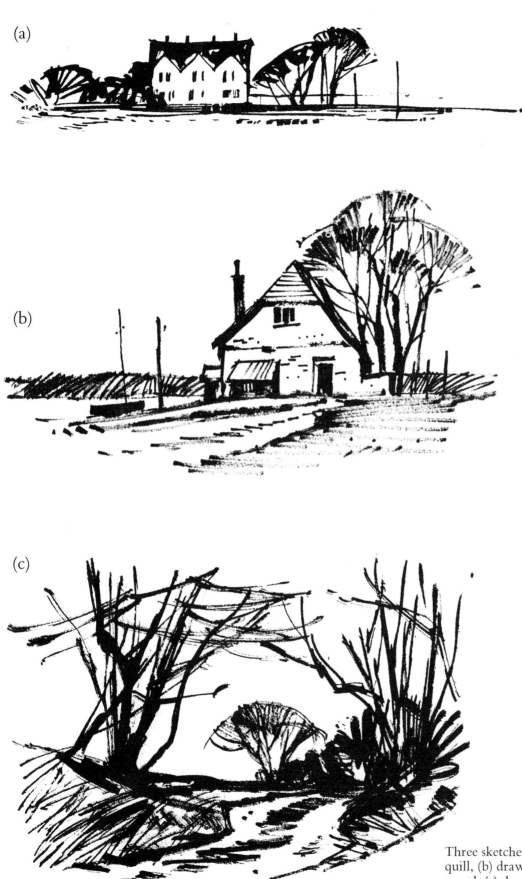

Three sketches (a) drawn with a
quill, (b) drawn with a piece of
wood, (c) drawn with a reed.

variety of styles in hardwood or light metal. Many are too light to be practical in windy weather. The usual method of stabilizing is to suspend a large stone from the easel on a string. Alternatively, the added weight of your paintbox on the easel will help to increase stability. Some wooden tripod easels will take brackets fitted into the leg slots to support a box, and I have found this system very practical and workable. It is much more efficient for the paintbox to be at waist level in front of you.

Spikes at the foot of the easel need to be protected with corks when the easel is carried.

Indoor easel For painting indoors the easel must be sturdy and strong, and weight is not usually a problem. Outdoor tripod easels are really too light for indoor work. The traditional radial easel has many advantages: it is very rigid and will hold a canvas of up to 76 in. (almost 2 m), but does not occupy much floor space. The dual-purpose radial has the top section jointed so that it can be inclined back to any angle, so it is suitable for oil, pastel or watercolour painting. I was fortunate enough to acquire an old-fashioned wind-up studio easel some time ago, but I still make occasional use of the radial.

I have used a combination folding studio easel and drawing table and found it very practical. If you paint in watercolour and need a shallow angle to paint and draw on, the table/easel is ideal. They usually adjust to take a large canvas and can be firmly set at any plane between the vertical and the horizontal. This type of easel takes up as much floor space as a small table but folds flat.

Where space is really restricted a radial easel and a tea trolley on wheels to take paints, brushes and palette is about the simplest and most convenient set-up.

Pochade.

MEDIA, MATERIALS AND EQUIPMENT

Stool

Standing at your easel allows greater freedom of movement and makes it easier to view the painting. But if you prefer to sit down make sure your stool is sturdy and comfortable, without being too heavy to carry. One of the most comfortable stools is the light metal tubular type with an ample nylon fabric seat. A folding chair is a luxury only practicable if you have a car. Avoid arms, which are restrictive.

Pochade

A small oil colour box measuring approximately 12 × 10 in. (305 × 254 mm), and extremely useful for outdoor work. Palette, paints, brushes and dippers are contained in the box and holds a painting panel in the lid. The box is held by a thumb-hole underneath and rests comfortably on the arm. A splendid old-fashioned piece of equipment, unfortunately not widely available today.

Viewfinder

An aperture approximately 3 × 2 in. (76 × 51 mm) cut into dark-coloured card is a useful device for visually isolating a subject from its surroundings. A piece of thread fixed across the middle of the horizontal and vertical will help the beginner to determine composition, and avoid getting the main subject or horizon line across the middle.

Photographic transparency frames are sometimes used as viewfinders, but the frame surround is too narrow in width to isolate the subject sufficiently. An aperture cut out of the back cover of your sketchbook will prove much more effective.

Sketch bag
An alternative to the purpose-made artists' sketch bag is an old school satchel. Capacious and with outside pockets, it is ideal for carrying the materials for small sketches or drawings. A fisherman's bag is another good alternative.

I often paint outdoors without using an easel and carry an oil colour box, stool, painting boards, etc., in an ex-army backpack. The wet panel fits inside the oil colour box between grooves which prevent movement. With everything in a pack on my back walking is easy and comfortable. If I take an easel it slots through the straps of the backpack.

Canvas and panel carrier
Carrying wet paintings is simplified by a purpose-made carrier. Most enable hardboard (Masonite) panels to be carried as well as stretched canvases.

If you don't have a carrier wet canvases can be separated by canvas pins with double steel points, then carried in a strap or string. A pastel painting can be carried tightly sandwiched between two pieces of hardboard, the four sides being fastened with strong spring clips or large rubber bands.

Drawing board
For outdoor work a piece of rigid ply or hardboard (Masonite) will provide a satisfactory support. It should be cut larger than the average size of the paper you use. The paper can be secured to the smooth side of the hardboard with masking tape or spring clips. Never use drawing pins or thumb tacks to fix paper to any type of drawing board; masking tape adheres to the board quite firmly and does not harm the surface. If you have a drawing board already pitted with drawing pin holes buy a thick sheet of plastic from a drawing office suppliers' and overlay it on the board.

Secure it at top and bottom with clips or masking tape. Clean with household cleaner on a damp cloth.

I have a draughtsman's 42 × 32 in. (1067 × 813 mm) drawing board on a stand and I use it constantly, not only for drawing but for painting pastels or watercolours, and also for accurately setting out mounts (mats) and squaring off paper and card.

Brush case
A thin cane roll-up table mat makes a very good substitute for a brush case. Thread cotton tape through the divisions to hold the brushes in place. Another alternative is to cut a piece of stout card longer and wider than the brushes when they are lined up together. Lay the brushes on both sides of the card and secure with an elastic band.

Always make sure your brushes are thoroughly dry before you put them away, or they may develop mildew.

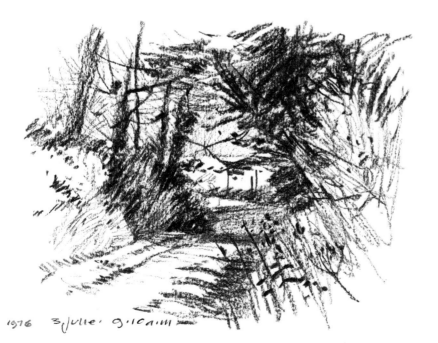

3 Elements of a painting

Composition

Basically, a landscape painting is an arrangment of shapes into a simple or complicated pattern. The arrangement of a painting, like the appearance of a book jacket or of a piece of packaging, is fundamentally a matter of design. If you regard composition as the skeleton of a painting then it will assume the right degree of importance.

Selecting a subject presents any number of problems to the beginner. Being confronted with a large canvas increases the difficulties. He does not know where or how to begin. Start off not more than say 20 × 16 in. (510 × 405 mm), and don't be afraid that working to a small size will cramp your style–on the contrary you will find that, using

a large brush, freedom of expression and spontaneity are more attainable on a small scale. Of course later, when ready, working to a substantial size can be very rewarding.

Begin with a simple arrangement of just a few elements. Except where there is a rare natural ability, success in complex design comes only with understanding of and long practice in the basic principles of composition. As a beginner try not to make your painting too busy. Selection is the key.

If you are not familiar with the problems of composition in landscape the viewfinder will help you to understand the principles. Move the viewfinder horizontally and vertically across the landscape. Move it slowly and think about each part as it appears in the aperture. A slight adjustment may reveal an improvement in the composition. Practise indoors and make some small rough sketches of the variations. The landscape painter must be prepared to modify what he sees: he will not include everything in his picture, just because it happens to be there. On the other hand, to remove a prominent feature in a landscape in the hope that the composition will improve is usually a bad mistake. A lot of skill is required to overcome the problems caused by major revisions in a composition, and too many modifications will alter the character of the subject. It is preferable to find a solution to a problem without resorting to haphazard deletion. I seldom find it necessary to alter a composition when working outdoors. I may move an object a little, or play down an emphasis, but if there is a problem I usually try to solve it by changing my vantage point. A commonplace view of fields and

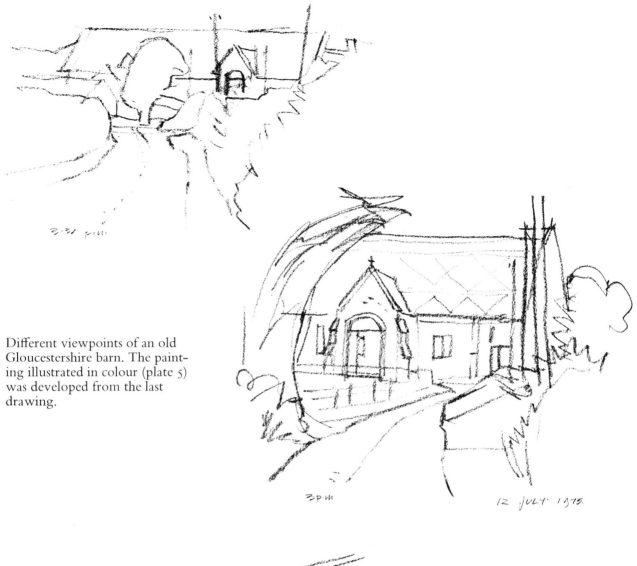

Different viewpoints of an old Gloucestershire barn. The painting illustrated in colour (plate 5) was developed from the last drawing.

ELEMENTS OF A PAINTING

trees can often be given interest by altering the eye level. Try sitting down on the ground instead of standing. The composition will shift to an emphasis on the ground with a narrow portion of sky. Low or otherwise odd angles should however appear natural, not contrived.

Sometimes the composition of a painting will be physically improved by altering the format, perhaps from a square to an oblong. Masking off parts of a painting illustrates possible variations.

Analysing composition in the paintings of such masters as Constable, Corot, Pissarro and Turner can be very rewarding. Lay a smooth thin sheet of tracing paper on top of a reproduction and draw in the main shapes and rhythmic lines. Note the harmonies and contrasts of colour, tone, line and shape. And keep your rough sketches: all of them are useful for further ideas and development.

In landscape painting the quality of light and shade on the landscape determines the tone of objects, which affects the pattern of your painting. Changing light alters the tonal composition of a landscape by shifting the emphasis of light and shade. From a single composition a number of variations are possible, not only by the rearrangement of objects but by understanding the changes effected by changing light. A simple example is provided by houses in silhouette. Light falling behind a row of houses will cast into shadow the vertical surfaces facing the viewer. Horizontal and angled surfaces such as a road or roofs reflect the light, creating a pattern. If the light illuminates the houses and road from behind the viewer the detail and shapes are more clearly defined.

Before beginning to paint plan carefully what you are going to do. Lack of preliminary planning almost invariably results in a poor and contrived composition. This planning should include an analysis of tone and colour.

How to go about laying in your composition? Personally, I begin drawing in straight away with a largish brush. I like to begin like this because it is a direct and positive approach. You may prefer to begin by drawing the layout with charcoal and dusting off afterwards. Whatever your technique the important thing is to establish a firm structure of composition at the very beginning. First position

Three different effects of light on a simple subject, showing how tone values change and unify features.

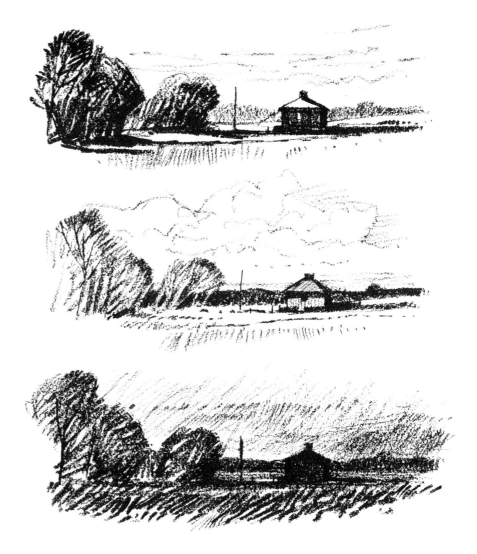

the horizon line. This determines the proportions of landscape to sky. The next step is to indicate the outline shapes of main masses and principal rhythmic lines, ignoring all minor detail. Paint in the general tone of the large masses with a diluted mixture of ultramarine and burnt umber. At the same time indicate the strong areas of shadow.

Establish the centre of interest. One of the principles of composition is that the eye should be taken not out of the picture but into it somewhere near the centre. If the interest is focused within an imaginary circle just off centre then the viewer's eye comes to rest within that area. Foreground gives many painters a great deal of difficulty. Avoid the temptation to include a lot of detail at the bottom of the painting simply because it is nearest. The 'fringe' effect often to be seen in the paintings of in-

ELEMENTS OF A PAINTING

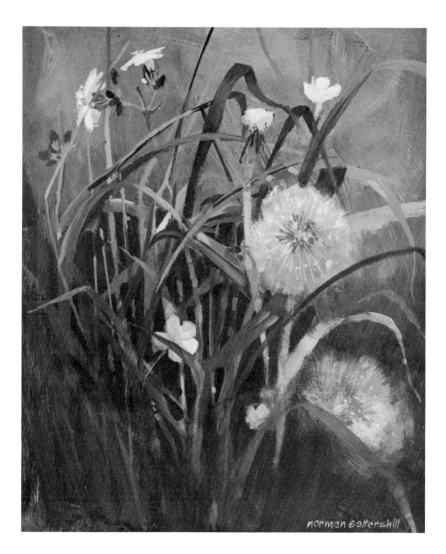

Flower study. Oil on hardboard
12 × 10 in./305 × 250 mm.
I began this painting with a
transparent stain of prussian blue
and yellow ochre over a white
ground. As the painting
developed, areas of the stain were
allowed to show through, in
particular the deepest shadows. It
is not necessary to obliterate
underpainting.
The puff-balls are not white but a
subtle yellow ochre with cobalt
blue and white.
Flower paintings need as much
consideration of light and
atmosphere as landscape paintings.
Be aware of top light all the time
you are painting.

experienced artists completely unbalances a composition.
The immediate foreground is unimportant unless you
deliberately decide to make a feature of it. I sometimes
place a close-up of plants in the foreground of my paint-
ings, pushing the background out of focus in tone and
colour. The foreground then becomes the principal part of
the composition, but it must balance with the middle
distance if it is not to look bottom heavy. More often I
prefer to leave the foreground empty but suggestive of
detail. Putting the foreground into a subtle and gradated
shadow leads the interest gradually into the composition.
As my painting progresses I continually relate foreground
to middle distance and distance, adjusting tone values,
colour and shape, for these form the pattern of composi-
tion.

Perspective

Perspective is the system by which the illusion of depth and recession is created on a flat surface. Linear perspective is a geometric method of achieving this. Aerial perspective refers to the modifications of colour which produce an impression of depth. The study of perspective can be as extensive as the student wishes to make it, but a knowledge of basic principles is sufficient to solve most of the problems which arise in landscape painting. A few hours each day for a week spent studying perspective will give you all the theory necessary as a foundation to work from. After that what you need is the working knowledge that comes from experience.

The basic assumption of linear perspective is that parallel lines diminish and converge as they recede to a vanishing point. If you look along a street, the road, buildings and people appear to converge and become smaller the further away they are. This is known as the principle of convergence and diminution. Early systems of perspective were based on a single central vanishing point. This system was adequate but restrictive, and in order to obtain greater naturalism a system was evolved using two vanishing points on the horizon, and more if necessary.

When you begin drawing or painting outdoors first of all you must establish your horizon line. The placing of the horizon line requires particularly careful consideration, governing as it does both the composition and the

52 ELEMENTS OF A PAINTING

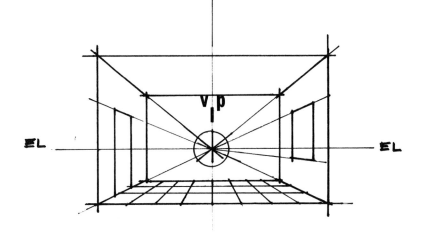

Single-point perspective is the easiest system to use, but it is limited and can cause errors of distortion.

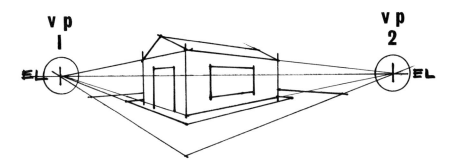

If the line of sight moves off centre then two or more vanishing points become necessary, because planes are seen obliquely. The two-point system because of its flexibility is the most frequently used and it covers most of the problems which concern the landscape painter.

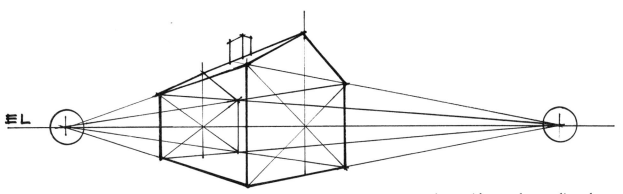

As an aid to understanding the perspective of a building draw in the geometric construction, using the two-point system of perspective.

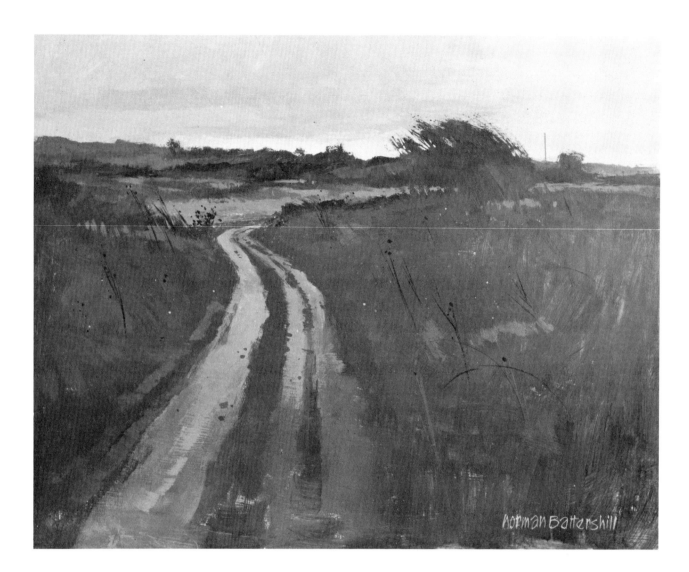

Track. Acrylic on hardboard
30 × 25 in./762 × 635 mm.
Placing the horizon line high
emphasizes the ground, because
that is what occupies the greater
area. A low horizon will give
emphasis to the sky.

perspective of a painting. The horizon line is determined
by the level of your eye: when you are standing it is higher
than when you are sitting down because your eye level is
altered. If you are not quite sure of the position of your eye
level, hold your sketchbook at arm's length straight ahead
of your eyes, holding the book flat and parallel to the
ground. All you should see is the edge of the book, which
is then on your eye level. A simple rule to note is that all
lines above eye level go downwards and those below eye
level upwards. Remember also that a low horizon gives
emphasis to everything above it. So a landscape painter
can make use of a low horizon line if he wants to emphasize
the sky.

Aerial perspective is based on the principle that colour is
modified by atmosphere and distance. Owing to the den-

ELEMENTS OF A PAINTING

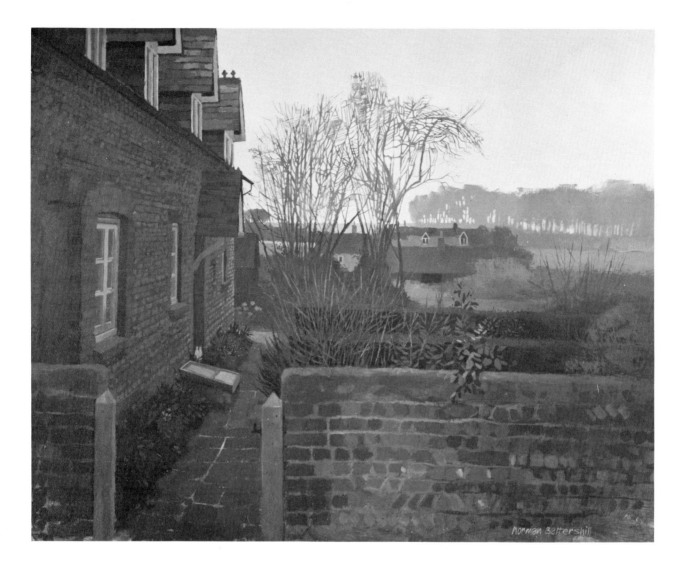

Quiet comes another day. Acrylic on hardboard 36 × 24 in./ 914 × 610 mm.
The atmospheric effect I tried to capture in this painting is the stillness of early morning.
The colour scheme is mostly grey-russet. Before beginning to paint I stained the panel with diluted acrylic burnt umber and then when it had dried I drew over the top with charcoal.
To achieve the lace effect in the leafless trees I blocked it all in with a burnt umber and ultramarine mixture and when it was dry cut out all the interstices with the sky colour. It took a lot of patience but in the end I got the effect I wanted.

sity of the atmosphere colours tend towards blue/grey as they recede from the observer. The landscape painter uses this to create the effect of recession. Modifying receding colour with grey or grey-blue helps to achieve the effect of distance. Sunglasses with good quality neutral lenses can be a help in perceiving this – tinted lenses reduce colour to tone and recession is more readily defined. Some landscape painters even work with sunglasses on, but this is poor practice. Look at the landscape for a few moments wearing the glasses and then lift them up.

Tone and colour

It is essential for a painter to learn to mix colour in a workmanlike and efficient manner. You are not going to achieve

the right colour by chance. It is sound practice to start to paint with a limited number of colours: when you have learned how to mix and extend the range of a few colours more can be added.

Tone (Value)

Tone (value) refers to the gradations of a colour from light to dark – e.g., burnt umber is a dark tone, lemon yellow is a light tone. We can also speak of the overall tone of a painting, describing it as being in a high or low key or tone. Variations of tone are achieved by adding to a colour black, white or the complementary colour.

A grasp of the principles of tone is essential to the technique of painting. Very often when the colour looks wrong the problem lies not in the colour but in the tone: or an area of a painting may look too predominant because the degree of light or dark is out of harmony with the rest of the painting.

For a landscape painter the problem of achieving the right tones can at first be rather daunting. The range of tones in nature seems infinite, from light to dark with countless subtle tones in between. To simplify the problem, limit the number of tones you are going to use. Looking at a landscape through half-closed eyes simplifies the mass of different tones. Select the darkest and lightest parts of the view and use them as extremes, relating other tones to them. Divide your painting into four tones, foreground, middle distance, distance and sky. Generally the foreground will be the darkest, the middle distance lighter, the background lighter still and the sky lightest of all. You will often find that a painting gains in strength and simplicity by being restricted to only four tones. Ignore detail for the moment and concentrate on establishing the major tone values. The detail can be added later.

You can make two simple aids to determining tone. First, a tone scale. Divide a 12 × 2 in. (305 × 51 mm) strip of white card into nine equal divisions. Using either acrylic or poster colour paint one end division black and the other white. Paint the other divisions in tones graduated from black to white by adding increasing quantities of white to the black. Allow for the difference in tone which will

Brighton from Race Hill. Acrylic
on hardboard 30 × 25 in./
762 × 635 mm.
This painting of a view of
Brighton illustrates how the tonal
method is used in a detailed
work. The painting is divided
into five tonal planes. Balance
and recession form a pattern of
subtle tones; some are clearly
defined in contrast while others
are closer together. A colour
reproduction of this painting
appears in colour plate 6.

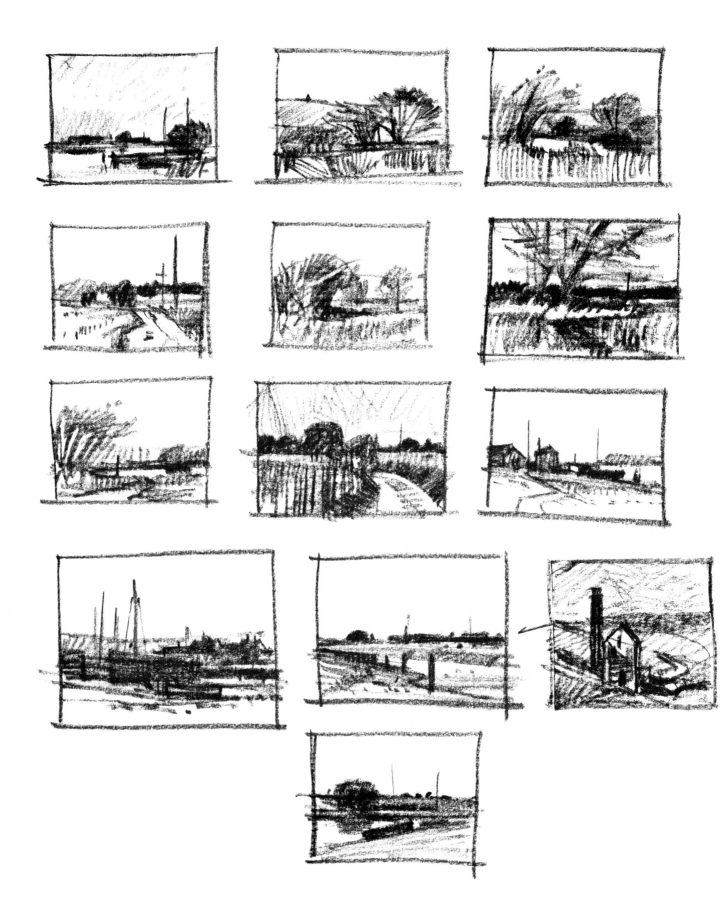

ELEMENTS OF A PAINTING

Demonstration: tone sketches
Tone drawings (left) help in working out ideas for a painting from the imagination. They are also an aid to determining the light and shade on the landscape before you begin painting. All the illustrations here are in charcoal pencil on writing paper. The reproductions are the actual size of the originals. Working out ideas on a small scale, apart from being quicker than doing larger drawings, fosters compact composition and tone. These small sketches are also a good method of analysing composition. Any mark in such a small space is immediately apparent in relation to the design.

If the idea does not work I move on to doing another drawing. Rubbing out or alteration is not necessary, it is easier to start again. Sometimes one idea suggests another and the sketches become a sequence leading up to the final solution.

I have developed paintings from most of these drawings. The one which was produced from the third drawing down on the right is illustrated in colour plate 2.

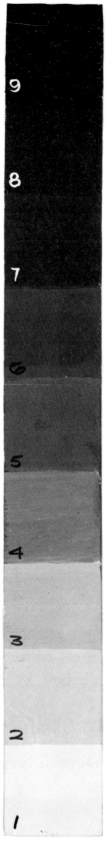

Tone Scale.

occur when the colour dries. When they are dry number the divisions from 1 to 9. You will then be able to determine the tone of a colour by measuring it against the scale. As an exercise paint a 1 in. (25 mm) square of yellow ochre. Match the colour to a grey (it is likely to be no. 2). Now try other colours.

The second device, even simpler, can be made from a piece of white card about 6 × 3 in. (152 × 76 mm). Pierce in it three holes $\frac{3}{8}$ in. (10 mm) in diameter, spaced 1 in. (25 mm) apart. You will find that areas seen through the holes can easily be compared for tone values.

Before I decide on a colour scheme for a landscape painting I give first consideration to the atmosphere I wish to depict. This determines my tone value. Then I think about colour. That comes second. By determining an atmospheric effect before beginning to paint I know what I am going to do because the pattern of light and shade has been roughed out. I modify colours I see in the landscape to suit the atmosphere and quality of light in my painting.

I don't make colour notes on outdoor sketches but rely on my visual memory and imagination for colour. Many of my outdoor drawings are linear sketches. If I am painting entirely from imagination I work out the composition and tone with conté or soft pencil sketches first. Drawing a few inches square ensures the simplest composition and tonal mass. There is no room for anything else and all detail is eliminated.

If you have difficulty in mastering tone try painting in

19 June. 6.30 p.m. raining

monochrome for a while. When you have completed several pictures using only greys, reproduce them in colour. Overpainting monochrome with colour, a technique much used by early oil painters, is also a help. And working from black and white photographs, providing they are not used slavishly, can teach you a great deal about tone. Atmosphere and light on the landscape are often quite as beautiful in a black and white photograph as in colour. Select a simple subject composed of a few tones, and interpret the subject freely. Use the photograph as a starting point and let the imagination take over as the painting progresses. Many of Sickert's portraits and his street scenes of Dieppe were painted in his studio from photographs. Degas also made good use of the camera.

Colour

The theory of colour is immensely complicated, but the chief concern of the painter is with the principles of tone (or value), chroma, hue, tint/shade and temperature.

Chroma is the intensity of colour, as distinct from tone. Bright red for example becomes a deeper tone but loses intensity if a touch of black is added to it. Chroma also refers to brilliance.

Hue refers to the individual quality of colour. For

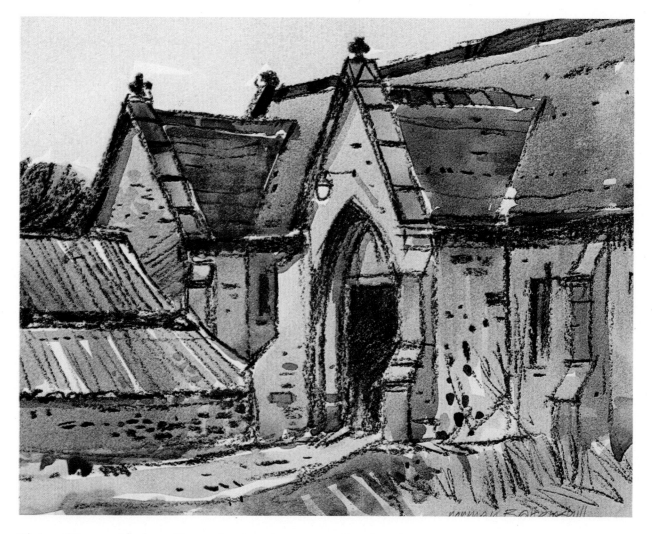

Plate 5 *Gloucestershire barn*. Charcoal and wash on watercolour board
10 × 8 in./254 × 203 mm. I developed this painting from a pencil
drawing. I drew it straight in without any preliminary pencil lines,
a testing exercise which strengthens directness and sense of perspective
and proportions.
A long time ago this elegant building was a chapel, but now it stores
hay and is a roosting place for chickens.

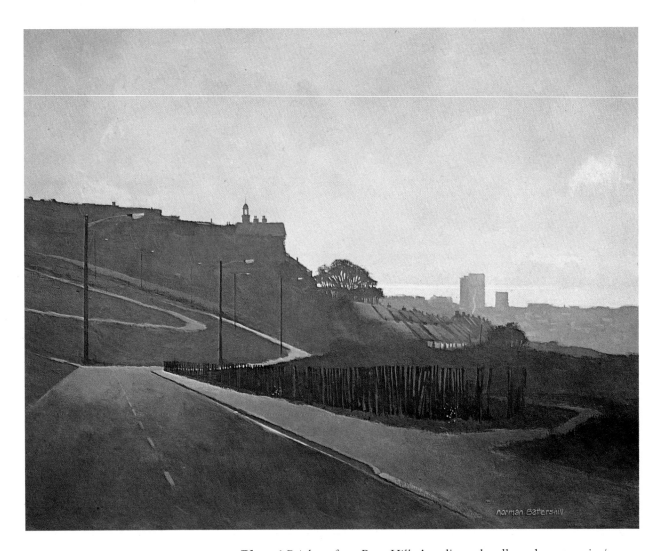

Plate 6 *Brighton from Race Hill*. Acrylic on hardboard 30 × 25 in./ 762 × 635 mm. A studio painting; the colour scheme and atmosphere are imaginary. To convey the atmosphere of early morning I deleted all unnecessary detail and made full use of silhouetted shapes. The sky has faintly discernible clouds, anything positive would detract from the misty effect of light. A wisp of smoke and a line of washing give a touch of life and movement to a sleepy landscape. All the colours are muted in tone except for the accents. I carried out the underpainting in deep purple and built up on top of it with grey-blue to suggest haze.

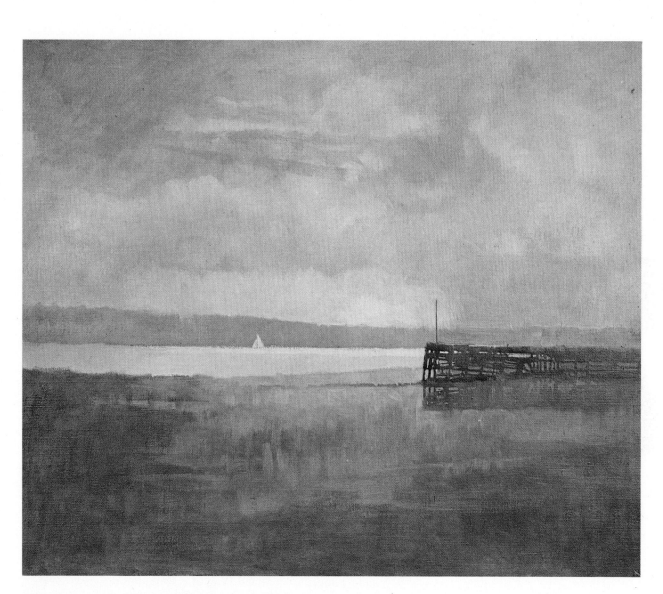

Plate 7 *Returning home.* Alkyds on hardboard 24 × 20 in./
610 × 508 mm. A studio painting developed from a small black and
white drawing.
I was concerned with capturing the feeling of space and light, and to
give emphasis to this the composition is kept to a few simple elements.
The old jetty adds contrasting detail to the large areas of sky and
mudflats. With a subject like this it is essential to achieve tonal unity by
muting colours.

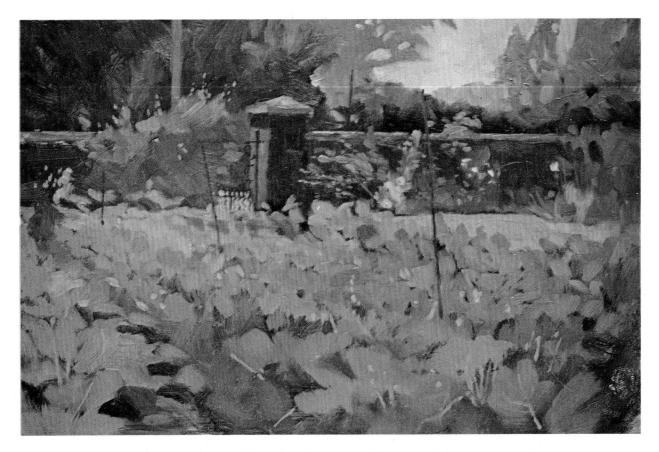

Plate 8 *Cabbage patch*. Oil on hardboard 12 × 8 in./305 × 203 mm.
I painted this when I was tutor on a painting holiday run by *The Artist*.
It was held at the Gloucestershire College of Agriculture which offered
a never-ending source of inspiration in and around the gardens and
greenhouses.
The cabbages, with the interesting texture of their blue-green leaves,
were a delightful subject. The old brick wall with a suggestion of
flowers against it provides a useful foil of colour, and the sticks help the
composition by slowing down the angled movement of the cabbage
patch. The most prominent shape is the gate pillar, which I took care
to place well off centre.
It was a very hot afternoon with strong sunlight and I modified tones
to achieve unity.

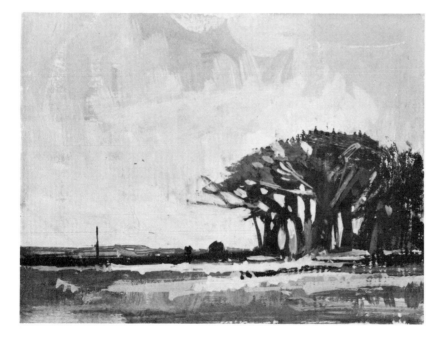

Outdoor sketch with *conté*
pencil 8 × 4 in./203 × 102 mm.

Demonstration painting. Oil on oil
colour paper 20 × 16 in./
508 × 406 mm.
It is not at all necessary to have a
busy subject for a painting – a
simple subject often has more
force and interest.
I have done this demonstration to
show how to start off with a
thumb-nail sketch, with just one
main feature.
I have made a low horizon to
give emphasis to the group of
trees. The dark band of colour
joins the pole and the ground to
the trees.

ELEMENTS OF A PAINTING

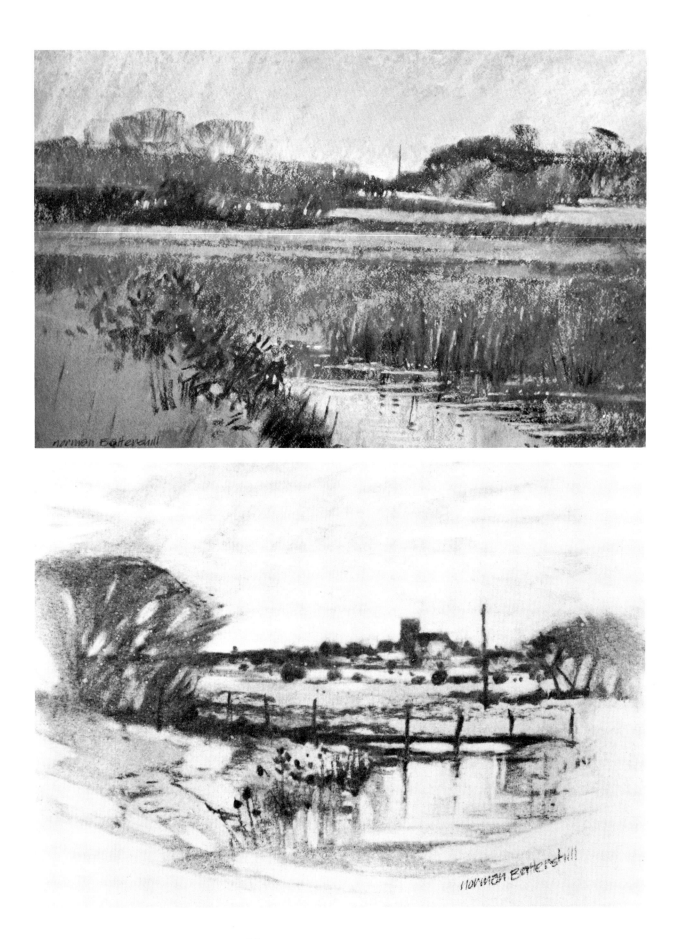

ELEMENTS OF A PAINTING

example, ultramarine, cobalt and prussian blue are all blue colours, whatever the variations in other characteristics.

A *tint* of a colour is produced by weakening it with white.

A *shade* is produced by mixing it with black.

Temperature refers to the warmth of a colour. Orange is warmer than blue, blue is cooler than yellow.

On the principle that warm colours advance and cool colours recede warm and cool colours are used to give an illusion of depth or recession to a painting. But nature has a way of defying colour theory. For example, the colours of sunset are bright and warm with orange, pink and red, but always atmospheric and recessive. To render such an effect is almost impossible because we are trying to depict light. Turner is the only painter who ever interpreted the wonderful transparency of infinite space and light.

Modifying colour to achieve recession is of paramount importance to the landscape painter. Distance is affected by atmosphere; for example, a red roof in the distance will have most of its colour muted by a grey-blue suggestive of space and depth. If the roof is not modified by greying it will be too assertive. The landscape painter must ignore his knowledge of local colour and observe the true colour resulting from the influence of light and distance. He can *know* that a tree is green. Thoughtful observation may reveal that it is primarily a brown-green with a lot of grey-blue reflected from the sky; or it may be mauved by distance.

The palette

When selecting the colours for your palette start with red, blue, yellow, black and white. I would suggest vermilion, ultramarine and chrome yellow. Avoid prussian blue, alizarin crimson and scarlet lake at first. They are powerful colours and need careful handling. Later on, when you become familiar with a wide range of colours, you will be able to cope with these more easily. Some painting books advocate prussian blue, but I find it has too much of a green tinge for use in skies. For foliage it has a beautiful strength and transparency. When it is mixed with yellow the green produced is clear and strong. Occasionally I use

Outdoor sketch. Pastel 14 × 8 in./ 356 × 203 mm.
A late afternoon sketch when shadows are long and the source of light is low.
I used grey scrap paper, being careful not to overwork it to avoid blocking the slight texture.

Sussex landscape. Charcoal on tracing paper 9 × 6 in./ 229 × 152 mm.
Charcoal sketches like this one serve the useful purpose of working out tone values and design so that the painting is established at an early stage.

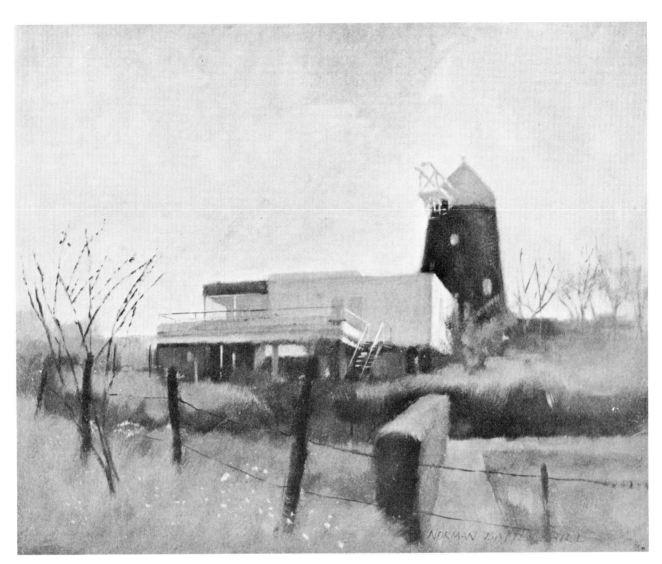

House and windmill. Oil on hard–
board 22 × 18 in./559 × 457 mm.
The main advantage of the
camera for the artist is that while
he can make a detailed drawing
of a subject the camera records
from different angles in a fraction
of the time in situations and
conditions sometimes impossible
for the artist to work from.
I selected this viewpoint because
the garden hedge led towards the
house and framed an interesting
box structure against the cone of
the windmill. The sun deck is a
main feature and adds a further
projection from the box-like
structure. Because the subject
included the disused windmill I
tried to get the feeling of space
and air.
Painted from a black and white
photograph.

ELEMENTS OF A PAINTING

prussian blue mixed with yellow ochre for rich shadows in foliage, or with burnt umber for blacks and greys. Be careful about the use of black. Too much black reduces colour to a muddy dullness. As an alternative to darkening a colour with black add a little burnt umber instead.

Arranging colours on the palette in a recognizable order enables a colour to be selected quickly. Make a habit of setting out the colours on your palette in the same order each time. Group the blues, yellow and browns, etc., so that your palette has this sort of sequence: ultramarine – cobalt – yellow ochre – cadmium yellow – raw sienna – burnt sienna – burnt umber – vermilion; or if you prefer divide your palette into warm and cool colour areas. Allow plenty of space in the middle for mixing, and around the white to keep it clean.

Choice of colours is very much individual and even if two painters have exactly the same set of colours the results will not be the same. I don't use many colours and prefer lower tones or values. My pastel paintings are slightly lighter in tone or values. The oil and acrylic colours I generally use are:

Ultramarine. A warm blue, strong but not assertive as prussian blue is.

Yellow ochre. A soft earth colour. Mixed with ultramarine it produces a rich, low-tone green.

Cadmium yellow. Mixed with ultramarine, prussian blue or black produces a powerful green. Add burnt umber or yellow ochre to lessen the brightness.

Cadmium red, cadmium yellow and a touch of white makes a warm orange. Ultramarine and cadmium red make a good purple. Modified with yellow ochre the colour is a good mix for distant hills.

Cadmium yellow deep. A lovely, sunny orange. With a touch of ultramarine or cobalt blue and white it makes a subtle pale grey.

Burnt umber. Added to ultramarine gives a rich, warm black. Mix with lots of white and a beautiful range of greys will emerge. Add a touch of yellow ochre and the greys become more silvery. I use burnt umber also for skies, roads and mixing with green.

Cadmium green. A wonderfully crisp green. Mix with

1976 June 14 3pm

white and it becomes a sunlit grass colour. Soften it with yellow ochre if you find it too sharp. I use cadmium green sparingly as a focal point of light on distant fields or perhaps for other carefully selected areas; the moderation of a colour accent gives it more impact than indiscriminate use.

Sap green. Mixed with plenty of white produces a useful light green.

Titanium white. Flows and mixes more easily than flake or zinc white. It is not stiff and responds to brushing out.

For watercolours I use lamp black, cobalt and ultramarine blue, yellow ochre, burnt umber, burnt sienna, viridian and winsor red.

I find that this limited range of colours gives me ample scope for landscape painting. Every now and again I add a new colour to my palette so that I don't get into the habit of automatically choosing one set of colours. But working to a limited palette outdoors is a discipline worth developing: don't let the great profusion of colours in nature distract you from the more important concerns of light and atmosphere.

Colour mixing
Be methodical in your approach to learning about colour. You will progress faster in the end if you concentrate on a few colours at a time.

ELEMENTS OF A PAINTING

The colour wheel is the spectrum arranged in a circle. It consists of the three primaries, red, blue, yellow, from which in theory all other colours are produced, and the secondaries, orange, green and purple. Each primary has its complementary in the secondary produced by a mixture of the other two. Tertiary colours are produced by mixing the primary and secondary colours.

On the left side of the wheel are cool colours and on the right warm colours. Each colour has its complementary directly opposite. For example, if your painting is predominantly blue/violet, by referring to the colour wheel you will find that its complementary is yellow/orange. A colour is modified by mixing with the complementary or black.

Try some simple experiments in mixing. Keep separate brushes for light and dark colours and keep your brushes and colours clean, otherwise you will not achieve maximum benefit from the exercises.

Mix any two colours, make a note of the resulting colour, then experiment with two more.

Mix with any light colour a touch of black, to produce a shade.

Add white and a touch of vermilion and note the colour change.

Add white in increasing quantities to any colours of your choice.

Mix any three colours and add white.

Be systematic: start with the primary colours, then go on to more complex effects.

Colour mix formulae are sometimes frowned on, and certainly a long list does not serve much purpose. By experimenting with colour combinations you will quickly find out how to mix a required colour. But a few examples may offer a starting point to the inexperienced painter. I will use grey as my example, as landscape painting demands a good working knowledge of greys. Many effects of light and atmosphere are composed of grey, ranging from pale silver to the grey-brown of rain clouds; you will want to know how to get the grey-blue of a distant horizon and modify green to make it appear recessive.

Mixing black and white produces a negative grey, but adding another colour will turn it to a more interesting shade.

To black and white add separate touches of:

Burnt sienna
Burnt umber
Orange
Yellow ochre
Ultramarine
Raw sienna

The range can be extended by adding further colours of your choice.

Personally I seldom use black and prefer to get greys by mixing different colours. The following is a list of a few oil colour combinations you might try.

Burnt umber + ultramarine + white: produces a warm grey and a wide tonal range from almost black, depending on how much blue is used.

Cadmium yellow deep + cobalt blue + white: a beautiful soft grey.

Yellow ochre + ultramarine + white: begin with a touch of yellow ochre added to lots of white, add a touch of ultramarine. Too much blue will turn the colour green. Yellow ochre and white alone make a good mix for sunny clouds.

Burnt sienna + ultramarine + white: use less burnt sienna than ultramarine.

Try these watercolour combinations: black + viridian; cobalt blue + yellow ochre; burnt sienna + cobalt blue; winsor red + cobalt blue.

Mixing acrylics gives rather similar results to mixing oils. The problem does not arise with pastels as pastel colours are already mixed.

Harmony

Colour harmony is not confined to painting. Be constantly aware of the relationships of colour to colour and tone to tone. Learn to look and observe and develop your colour sense: what harmonies do you see around you at this moment?

Nature has a wonderful range of colour schemes that alter with every fluctuation of light. Notice the beautiful harmonies of an overcast grey day. Or natural objects: have you *looked* at stones and pebbles? Weathered posts and rusting ironwork reveal the most exciting colours and textures. I cannot repeat too often that the landscape painter acquires his knowledge of nature's colours by close observation and painting outdoors as often as possible.

Look at man-made harmonies. Studying the paintings of the masters and of contemporary artists is of course the time-proven way of learning. But consider too professional interior design. An elegant use of colour is often shown in glossy design magazines.

Combine constant observation with practice in mixing and blending colours yourself.

When you come to painting, harmony of tone and colour must be considered in relation to the atmosphere of the subject. All the time you are mixing or applying

Sussex cottage. Acrylic on hardboard 15 × 12 in./381 × 305 mm. In this painting I was concerned with large shapes and a colour harmony of low, rich tones. The colours and atmosphere are amber. The effect of the light is that of summer heavy with heat. In front of the Sussex cottage the corn is ripe and deep gold, across it a long shadow falls from trees out of the picture. The corn was so high from my low eye level that the lower windows and the door could not be seen at all. Patterns in landscape are evolved by simplification into shapes. The washing on the line repeats the window shapes of rectangular patterns, echoed again in the chimney stacks.

colour a sense of space and atmosphere must be present to you. The landscape painter has to be constantly aware of this until it becomes an integral part of the painting.

Before beginning to paint you must have a firm idea of whether your painting is going to be in a light, medium or dark tone. Having established that, put on the canvas a small area of your darkest dark and one of your lightest colour. These will be your two extremes of tonal scale and you must keep within them. Some pastel and watercolour painters also place patches of the colours they are going to use on the margin of the paper, making a predetermined colour and tonal harmony.

The fewer colours used the better chance there is of a harmonious colour scheme. A lot of bright colours may look attractive on the palette, but a complicated colour scheme requires very careful tonal control, which will present problems to the inexperienced painter. Try for a start keeping to not more than four colours, such as cadmium yellow, cadmium red, ultramarine, yellow ochre. Make simple colour sketches from these, adding lots of white and a little black.

Try also doing some paintings using one predominant colour in various shades and tones, with touches of the complementary. For example, the sky of a grey-green landscape may be slightly pink.

Don't take colour too literally. If, for instance, the sky in your subject is too bright it may be necessary to adjust

it tonally for harmony. A bright colour can be subdued by the addition of its complementary, or of grey; or try modifying it with a little of another colour on your palette. For example, if you add a slight touch of cadmium red to the sky, fields and buildings the warmth of the red will permeate your painting.

Some time or other you may feel that your usual palette of colours has got into the doldrums and seems uninteresting. If this happens, changing one or two colours will make all the difference in your colour schemes. Or if you habitually paint in the lower end of the tonal scale, try moving up into a higher key.

Local colour

Colours in a landscape have several aspects: local colour – light and shade – reflected colour – sky colour. All are affected by distance and atmosphere. The landscape painter must be aware of all these aspects. For example, the local colour of a tree is green, but into it is reflected the colour and light from the sky, shadow and half tones. Shadow cast from a tree is broken up by the local colour of the ground, reflection from the tree itself and light from the sky. Atmospheric colour (see below) influences every object in the landscape.

The *plein air* paintings of the Impressionists are examples of the breaking down of local colour into the sensations of light – look particularly at Monet's paintings of haystacks, cathedrals and water lilies.

Atmospheric colour

A pervading colour modifies and tints every colour in the landscape. To the observant and sensitive eye this colour is like a veil, never positive but always there. Or, to change the metaphor, you may come near to understanding what I mean if you imagine viewing the landscape through pale tinted clear glass. This atmospheric colour can most easily be seen in the extreme of mist. Everything is influenced and modified by the pervading grey. On a sunny day the atmosphere will be transparent and sparkling, and the colours may be tinged with pink or pale blue. In changeable weather the quality and colour of light varies not only

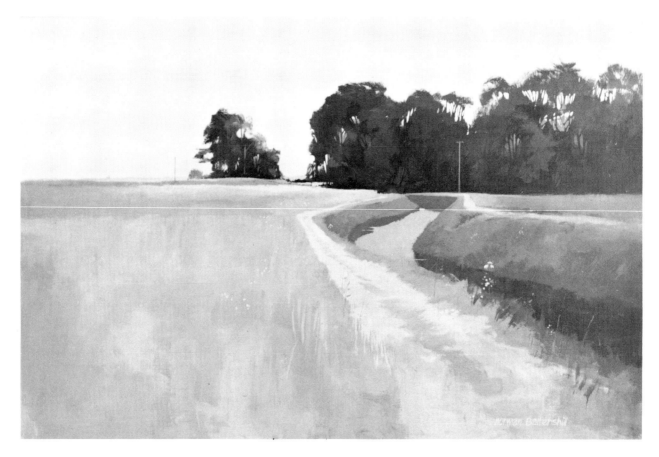

Near Steyning, Sussex
Acrylic on hardboard 48 × 34 in.
1219 × 864 mm.
The atmosphere I tried to
achieve in this painting is the
stillness and quietness of space. It
is a simple composition with very
little detail. The principal shapes
are the trees, river and track. I
placed the horizon line high to
emphasize the pattern of trees
against a narrow strip of sky. The
sky is grey-white gradating to
pale pink on the horizon.

from day to day but from hour to hour.

Before beginning to paint determine the pervading colour of the atmosphere.

Green

The colour green is predominant in the landscape, and unless the painter knows how to handle it his chances of capturing the effect of light and atmosphere are very slight. Unfortunately, green also presents the inexperienced landscape painter with more problems than any other colour.

At first students often despair at the monotony of 'all that green'. If this is how you feel I urge you yet again to *look*. Notice how the colour is affected by constantly changing light and atmosphere. The colour of light may have a tendency towards grey, blue, yellow or sometimes pink, so already there are four colours which modify green. A common fault in beginners' paintings is a green fringe running across the bottom of the picture like an upturned comb. But look at the different areas of texture in a green field. Subtle changes of direction across the sur-

face become apparent, even slight hollows and undulations change in tone from other areas. A light wind ruffles and bends the surface of grasses into interesting patterns, changing the tone like the surface of a wind-swept sea. The more you look the more noticeable are the surface planes, texture, colour and movement. Blending and merging close-toned variations of green can give something of this feeling of light and movement. For contrast of style and perception, compare the cornfield paintings of Van Gogh and the silver quality of Constable's cornfields.

Practise painting many different greens direct from nature. Spend some time analysing the local colour of a tree or field, and then try to see what variations there are within that colour. My oil painting of rows of cabbages (colour plate 8) is an outdoor study painted on a warm summer afternoon in Gloucestershire. I was fascinated by the way the sky affected colours on the broad leaves. Doing this kind of painting is in itself a good method of analysing and learning how to paint a variety of greens in a small area.

Some beginners have particular difficulties in relating green to atmosphere and aerial perspective. Green in the foreground can present problems. Remember the simple rule that if the dominant interest of a painting is in the distance or middle distance the foreground should be unobtrusive. If the foreground of a subject is bright green

Summer field. Charcoal on paper
7 × 5 in./178 × 127 mm.

grass then the painter must modify the colour. As the foreground moves into the picture the colour can become more assertive.

The colour chart of one principal manufacturer of pastels shows a range of forty different greens, many of them wonderfully evocative of light and atmosphere. It would be an instructive exercise to try to match them in another medium.

For the following exercises use a piece of hardboard (Masonite) 24 in. (610 mm) square primed on the smooth side with acrylic primer, or if you prefer prime stout paper. A good ground is necessary to achieve satisfactory results. An absorbent surface will not give a true demonstration of the richness and hue of the colour.

At centre top of the prepared surface paint an inch (25 mm) square of cadmium green straight from the tube. To the left hand side paint in a series of gradated squares, adding increasing quantities of white until the cadmium green becomes a pale tint.

With a clean brush repeat the squares on the right hand side using increasing quantities of black until the colour becomes black.

Begin again underneath with a mixture of ultramarine,

Near Steyning. Diluted acrylic on grey paper 10 × 5½ in./ 254 × 140 mm.
This is a direct sketch without any preliminary drawing, painted outdoors on a warm summer afternoon.
I began by painting the darks, leaving some of the paper as a light tone, and grey paper has been left for the ground and posts. White was mixed with some colours to raise the tonal key, particularly in the sky. The colours soon dried, enabling me to apply opaque colour on the top cleanly without the underpainting lifting.

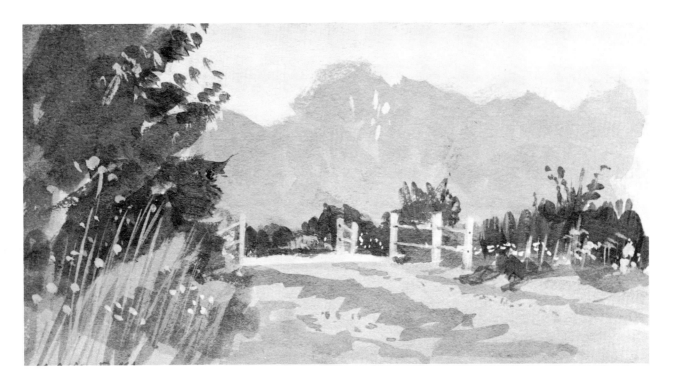

ELEMENTS OF A PAINTING

cadmium yellow and white and paint in squares to the left adding increasing quantities of white.

To the right hand side mix ultramarine, cadmium yellow and a touch of cadmium red. Add increasing quantities of white.

Now try ultramarine, yellow ochre and white.

Continue the exercises adding burnt umber, burnt sienna, cadmium red and raw sienna separately.

Experiment with:

Ultramarine + yellow ochre + white
Ultramarine + burnt umber + white
Ultramarine + raw sienna + white
Ultramarine + cadmium yellow + white
Prussian blue + burnt umber + yellow ochre + white
Prussian blue + cadmium yellow
Prussian blue + raw sienna + white
Yellow ochre + black + white
Yellow ochre + cobalt blue
Black + cadmium yellow + white
Cadmium green + black + white
Cadmium green + cobalt blue + ochre

The watercolourist will use water instead of white to lighten colour.

Be methodical with your colour tests. Don't mix more than three or four colours, and only add the slightest touch of the third or fourth to tinge the main colour. Too much mixing results in loss of hue and muddiness. Jot down the mix at the side of each colour. Then several weeks later try to match the colours without referring to your written notes. A tough exercise guaranteed to improve your colour memory!

Grey-green is a prevailing colour in the English landscape and one of the loveliest. A good grey-green can be achieved by mixing black and white to obtain the approximate tone of the green, then adding cadmium yellow or chrome yellow or one of the greens straight from the tube. Always mix the grey first. Yellow added to any of the half dozen or more blacks and greys manufactured in tubes will give an extremely useful range of greens.

Garden. Oil on hardboard
60 × 30 in./1524 × 762 mm.
Painted entirely out of doors. I
began by roughing in the main
shapes taking care to place the
doors and windows off centre.
The tree on the left creates a
balance. The colour scheme is
grey-green with pink flowers and
the russet brickwork of the
house. The bush on the right is
laurel. The sharp foreground,
though not very deep in tone,
helps to create recession.

The colours I have suggested are only a few of the many made possible by mixing, but they give a range which is adequate to cope with most of the variations of green we see in the landscape. The problem of finding the right green is not solved by purchasing a lot of tube colours. Two or three are quite enough to suit most needs. In oils I recommend cadmium green, terre verte and sap green; for acrylics sap green and emerald; and for watercolours viridian and hooker's green. Terre verte is a lovely green well worth including in your box. Although lacking in tinctorial strength, it produces a beautiful grey-green when mixed with white and a slight touch of ultramarine, burnt umber or raw sienna. Viridian is a very assertive green, and although it is popular with many painters care has to be taken when mixing not to overdo the quantity. Adding black or brown neutralizes the hue of viridian.

It is equally important to be careful in choosing your blue to mix with yellow to produce green. Make some comparisons between prussian blue, cobalt, cerulean and ultramarine: try each blue with cadmium yellow, then with yellow ochre. Prussian blue is a powerful colour for shadows, and produces a rich green when mixed with yellow ochre or raw sienna. Ultramarine is a good workhorse for landscape painting. Not too assertive, it is a versatile colour. Cobalt blue is cooler than ultramarine.

ELEMENTS OF A PAINTING

4 Sketching and painting outdoors

You will realize by this time that I regard working outdoors as extremely important to the landscape painter. It can also provide a great deal of pleasure and satisfaction. Sometimes too much emphasis is placed on the difficulties of working outdoors. The most awkward problem to contend with is constantly changing light, but the experienced painter accepts this as part of his job and enjoys the challenge.

From a practical point of view painting and sketching

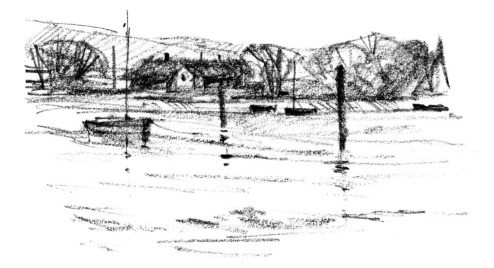

outdoors do demand a particular way of working. A convenient working method is the essential consideration. For example, it is not often practical to paint large pictures outdoors, except perhaps in the seclusion of a garden. I paint to various sizes but consistently work to 18 × 12 in. (457 × 305 mm), 12 × 10 in. (305 × 254 mm) or 9 × 5 in. (229 × 127 mm). Painting to the smallest size means that I can get all my equipment into an old school satchel if I want to travel with minimum gear. Here is a list of the painting equipment I carry in a satchel, depending which medium I am using:

Two 9 × 5 in. (229 × 127 mm) hardboard (Masonite) panels primed with acrylic primer on the smooth side (for oils or acrylics)

Six colours – titanium white, yellow ochre, ultramarine, cadmium red, cadmium yellow, burnt umber (much the same colours apply for oils, watercolours or acrylics)

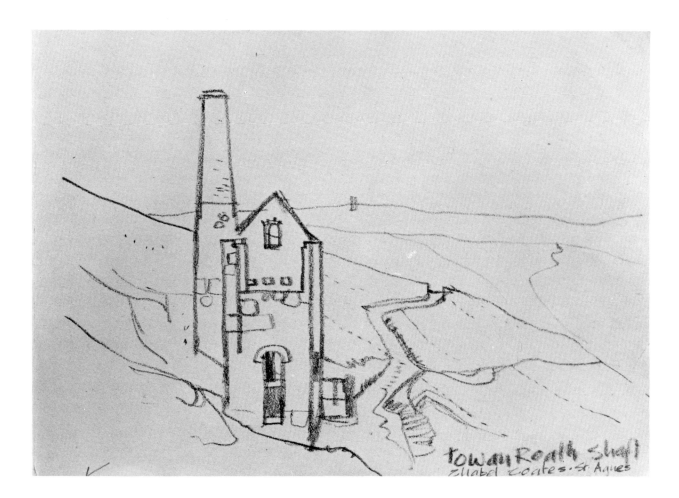

One or two oil colour bristle brushes or watercolour sables

A plastic beaker and a plastic water bottle (for acrylics or watercolour)

A bottle of turpentine (for oils)

Two dippers (palette cups) for turpentine and medium (for oils)

One paper tear-off palette

A lightweight folding stool

Some clean rag

Sketchbook (for watercolours and drawings), tinted paper (for pastel)

Pencils, charcoal, pastels and conté

Canvas pins (for carrying wet boards)

Small-size sketches do not require a easel; they can be supported on the knee without much trouble. It is sometimes worth taking an old picture frame. Four spring clips

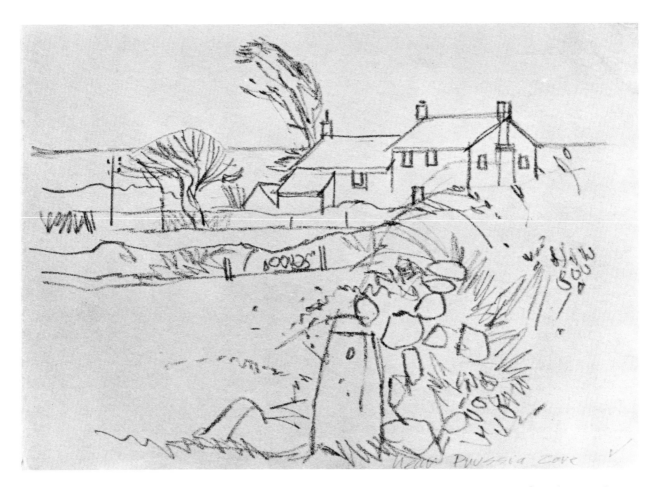

Cottages at Prussia Cove. Oil pastel on cheap paper 10 × 7 in./ 254 × 178 mm. The important part of the subject is the cottages, so I was careful to consider their position in relation to the page. Having placed them, the problem of composition was overcome. The tree, curved by innumerable winds, is placed off centre.

at the back will hold the panel or canvas firmly in place. The picture can then be painted in the frame supported on the knee, and it can easily be carried while it is still wet. For larger work of 30 × 24 in. (762 × 610 mm) and upwards I use my box easel. Sometimes I take an oil colour box which fits into a rucksack together with boards. To complete the equipment I may take a lightweight wooden tripod easel and some wooden brackets which will fit into the leg slots to form a support for the oil colour box. The added weight helps to stabilize the easel. I also use my pochade constantly and have fitted it with a webbing shoulder strap.

I often paint outdoors with acrylic. Its unique characteristic of combining two media in one is particularly useful when convenience and weight of equipment have to be considered. By watering down acrylic I can paint in a watercolour style. Using the colours with very little water enables me to paint in an oil colour style. (Weather is an important factor with acrylics, however. If it is warm

acrylics need a lot of dilution; cool weather gives the opportunity of painting more solidly as the colours do not dry so quickly.)

I do urge you to experiment with different media for outdoor painting. It can be argued that painting outdoors is difficult enough in itself, without increasing the problems by using an unfamiliar medium. But changing medium will extend your scope: the characteristics of each medium require different techniques for specific problems, and present a stimulating challenge. Of course it is better to work well in one medium than to dabble in many; but you may even surprise yourself with a new-found ability.

Selecting a subject

Remember you are hoping to enjoy your painting trip. Don't try too hard. The attitude of 'I must paint a picture at all costs' misses the point and is self-defeating. Set out to enjoy the pleasures of the countryside: be fully aware of all that is going on around you and let your approach be quiet and receptive. Light and atmosphere assume greater beauty the more observant you are: look for the patterns of light and shade. You will find endless possibilities in the simplest of subjects. As soon as you see something that

Trees and meadow. Diluted acrylic on grey paper 10 × 5½ in./ 254 × 140 mm.
Here thin washes of acrylic are tonally unified by the grey colour of the paper, a useful expedient when working rapidly. The grey of the paper provides a middle tone, and full use is made of it by leaving parts untouched with colour.

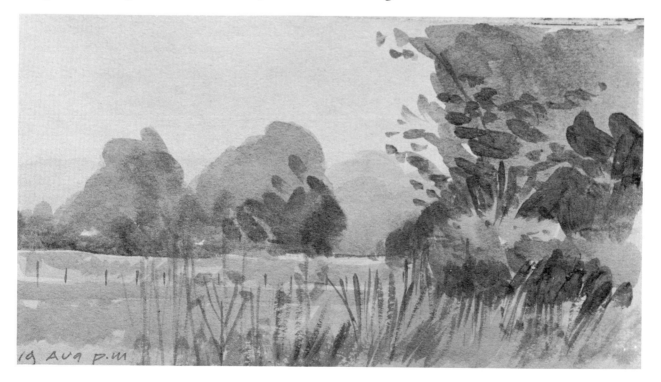

interests you, stop and find out why. It may be just an arrangement of light and shade, or an object in silhouette. The glamorous subject in the end often has less appeal than a small part of the ordinary landscape around us. Many of my outdoor paintings have very little in the way of composition other than a few features selected because they interest me, not with the intention of making an outdoor study into a studio painting. These are the painter's pages of learning. Some time or other the information may become part of a painting. If not it does not particularly matter: something has been learned just by the act of thoughtful drawing or painting.

It is sometimes a good idea to set yourself a theme, such as a hedgerow or a track. This can develop into very interesting possibilities.

My method of finding a subject is first to observe the landscape carefully. Having found a promising place I may use a viewfinder as an aid to looking more analytically with regard to composition. Moving the viewfinder and altering my vantage point will help to finalize the selection of the subject.

Perhaps after finishing a colour sketch you may find that it has not got the atmosphere you wanted but the composition seems all right. Instead of discarding it as a failure keep it, and at a later date have a fresh look. You may be able to use the composition as a basis for another painting. In this case before attempting to paint the subject again draw a number of tonal sketches, and solve the problem of light and shade.

Sketching outdoors

The outdoor sketch has particular value for the landscape painter. Each one captures a specific moment of atmosphere. Experiment with pencil, charcoal, chalk, pastel, oil pastel and conté. All are beautifully expressive for quick studies of light and shade and for cloud studies.

Pencil gives great scope for expression on a small scale. Constable's tonal sketches in pencil are not more than a few inches square, but have all the feeling of space, light and the open air.

3.3 pm. 15 June · 1976

21 June 7 pm.

1 July 8.30 am

Mechanical pencils with retractable leads are more convenient than the traditional wooden pencil. The retractable I use has a lead thin as a needle and does not need sharpening. Refill leads are available in several grades of hard and soft. When working with pencil try to avoid smudging with your finger to get an effect. A little here and there does no harm, but overdoing it will make a drawing look grubby and shiny.

If you initially find difficulty with pencil drawing, try the broader media of conté, pastel and charcoal. They are much easier to handle than pencil or pen, and after a while you will be able to approach pencil drawing too with greater confidence. The problem in drawing outdoors with charcoal and chalk pastel is the danger of smudging, which destroys the lovely bloom. I prefer to avoid the risk by using an aerosol fixative, but a pastel drawing carefully placed between two boards and firmly secured by strong spring clips or rubber bands is transportable without damage.

To encourage spontaneity practise with oil pastel, preferably vandyke brown. Oil pastel is impossible to erase and demands a positive approach; it does not smudge

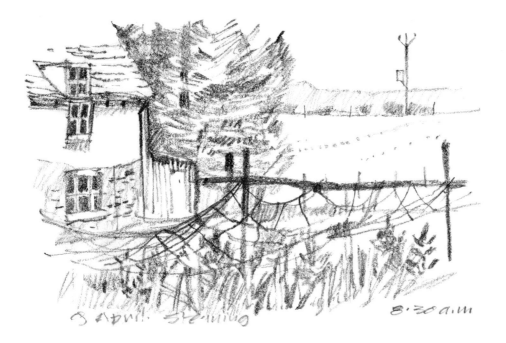

8 April. Steyning 8.30 a.m.

20 Sept. 1976 8.30 a.m.

Sussex pond. Charcoal on tracing paper 7 × 4 in./178 × 102 mm. An imaginative drawing in charcoal is a very good exercise to develop an understanding of the variations from light to dark. Although this sketch is small it is not at all difficult to achieve a sense of distance. Notice that the horizon line is quite dark but recessive. The effect of light is easier to work out with a broad medium such as charcoal.

easily and produces either a delicate fine line or a broad mass ideal for tone drawing.

Don't waste expensive paper for sketching, use the cheapest possible – children's drawing books are generally cheap and quite suitable for soft pencil, oil pastel, charcoal, conté or even pen. Let me repeat that in developing your sketching you should try all the media – and leave your eraser at home.

It is better not to strive consciously for a good drawing. Quality of line is spontaneous rather than studied and comes from lots and lots of drawing. Drawing should not be a contrived action but a means to record with sensitivity whatever interests you. A painter's sketchbook may consist of detailed drawings or slight notes quickly executed. Some of the drawings may be used for finished paintings or part of a painting. Sometimes I have done a drawing outdoors and wondered afterwards why I did it. Much

Saffron Walden Church from Jubilee Gardens. 2B pencil on paper 6½ × 5 in./165 × 127 mm. I had wandered into the town gardens of Saffron Walden and discovered this fascinating view of the church. I started to draw by indicating the height and depth of the tower and spire then let the drawing spread to fill the page. Provided you have included the main feature it is not always necessary to include the whole of a subject.

later, perhaps years afterwards, I have come across the drawing and realized its potential for a painting. A great many sketches will never have any direct use at all. But by the act of drawing the artist has concentrated observation, and to that extent contributed to his progress as a painter. Don't be put off by drawings that fail, either. Mistakes are all part of the process of learning.

Begin drawing by looking for the most important shapes and relate one against the other for proportion and location in the picture. Shape and rhythm are the important things to look for. Learning to look and knowing what to leave out is as vital in drawing as in painting. A simple study of light and shade is often complete in itself.

Spending a lot of time drawing unnecessary detail may result in loss of character. Draw first the part that interests you most. Speed is often essential because of changing light, and when this is the case the broad media of pastel and charcoal will be the most suitable: pencil is less capable of broad and rapid tonal work on a large scale.

I use both line and tone for drawing outdoors. The line method delineates rhythms and shapes, tone depicts form by light and dark areas. But develop your line drawing before practising shading. Very often a line drawing is all that is necessary for the start of an atmospheric painting done in the studio. The drawing may consist of a few lines without any preconceived idea of the mood the painting may take. Turner filled hundreds of sketchbooks with tiny landscape sketches in line; from these he developed monumental atmospheric paintings pulsating with light and atmosphere. Tonal drawing is most useful for painting atmosphere and light and shade. A quick method of producing a tone sketch is to rub charcoal or pencil dust into smooth paper. The darker tones can then be drawn on top and the light picked out with a kneaded putty eraser. Some interesting atmospheric studies can result from this method of laying in a ground tone. Begin with small sketches of about 6 × 4 in. (152 × 102 mm). Rub the pencil or charcoal against sandpaper so that the particles fall in the centre of the paper. Smooth with the fingers. The drawing will need protection from smudging: use a spray fixative or cover with paper.

Shadows will indicate the direction of the light source and establish three dimensions. Cast shadows often form interesting patterns and it is as well to draw these carefully for accurate reference. Shadows on buildings and undulating ground are sometimes complex but essential to the mood of a painting.

Painting outdoors

When you are working outdoors conditions will determine how you begin your painting. If the light on the landscape is reasonably constant it is possible to study the subject for a greater length of time, and your approach to

Near Steyning. Oil pastel on paper 12 × 8 in./305 × 203 mm. Oil pastel is ideal for expressing broad mass and line rapidly. I did this outdoor sketch at 8.15 on a bitterly cold October morning, so I was glad to have means of speedy expression. From this sketch I have developed several studio paintings, all with different atmospheric effects. The composition has not been modified at all in the sketch – I moved around to get it balanced rather than having to delete parts. It is not always necessary to make modifications to a sketch, because they can be made in the painting; more important is the need to include parts which give an interest, even if your sketch is not a perfectly balanced composition. The cattle fence here is an example of what I mean: in my sketch it is too near the edge of the paper, although it leads down into the picture.

setting out equipment and getting started can be leisurely. Fast-changing effects of light and shade do not allow for prolonged deliberation and decisions have to be made quickly. In some ways this can be an advantage to the finicky painter who wants to paint in a broader manner: there is no time to waste on unnecessary detail.

The first considerations are subject matter and composition. When these have been established it is time to turn to the effect of light. Painting outdoors is made easier by dividing the subject into a few planes established by tone values. Gradate the planes from dark foreground to paler distance. As you become more experienced with tone values you will be able to make the foreground lighter than the rest of the landscape if that suits the composition.

Having laid in your painting (see section on Composition, page 46), you can progress by building it up to a more complete statement. During this process be prepared to indicate an accent or atmospheric effect of light as it occurs. Trying to remember after it has happened is not quite the same. However, to alter the effect of light in your painting just because it alters in front of you is to miss the point. Too much changing about is tiresome and frustrating – when you consider your painting half finished it may well not require any more work.

In particular, working on a partially finished outdoor

The place to begin an outdoor drawing is sometimes determined by a feature in the landscape. In my sketch it was the large pole, and I began by placing it off centre. From this starting point the remainder of the picture took shape.

painting back in the studio is seldom satisfactory. There is more time for deliberation, and the result, more often than not, is the loss of the verve captured outdoors. Overpainting an outdoor painting will invariably result in obliterating the spirit of it. The only really successful way of exploiting an outdoor painting back in the studio is to develop another painting from it.

It is better not to strive consciously after the effect of light and atmosphere. Your painting may look mannered and overworked if you do. Be concerned only with the essentials. The questions you must ask yourself are what

effect you are after and how it can be achieved. If you are painting a study then the size of the picture is probably small, perhaps 12 × 10 in. (305 × 254 mm). So you must first of all decide whether you want to include detail or not. A broad approach is much more likely to capture atmosphere. Disregard all the nice little bits of colour and detail; add them at the end if, and only if, they contribute something.

It sometimes happens that the feature which first attracted you becomes secondary as the painting develops. An example might be a tree in blossom which looks attractive against a background of darker trees, a house and hills. Your composition, however, does not make full use of the tree as a theme and it becomes a distraction from the rest of the picture. At this stage you have to decide whether the house and the background are not in fact more important. If so the blossoming tree will have to be modified in tone and colour to assume a proper place in the composition.

You are the artist. To paint exactly what you see without any expression is not the intention. You must alter or modify the landscape as you consider necessary, in colour, tone or composition. Remember, though, that anything deleted or moved in the landscape will inevitably need something else in its place. Before resorting to drastic changes consider what can be done by modification. For example, the distant hills in my seascape illustrated on page 128 were actually a very prominent brown-green, and did not give the recession I needed. I modified the colour to a grey-blue which not only gave recession but created a better feeling of space and atmosphere. The same principle applies when you are painting light on the landscape. Providing the quality of the light is compatible with the sky the brightest part can be placed to suit your purpose: perhaps a line of light across distant fields, or cloud shadows emphasizing the point of interest.

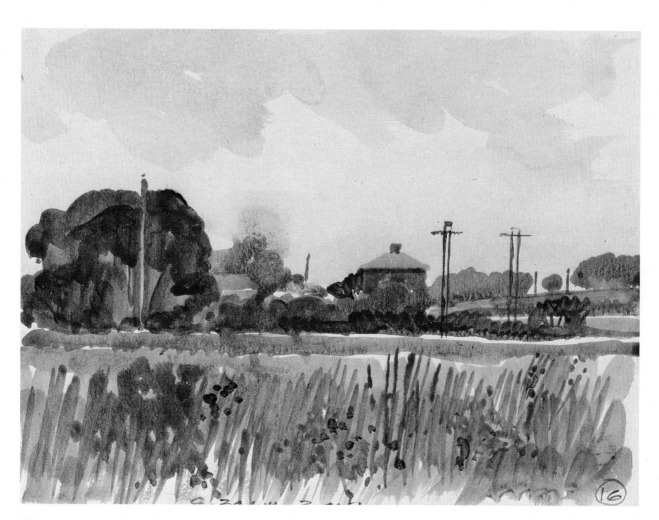

Plate 9 *Outdoor sketch*. Acrylic wash on paper 8 × 6 in./203 × 152 mm.
An outdoor sketch made in the fields near my studio. I began with a
wash for the sky and left the white of the paper showing through the
colours in the rest of the painting.

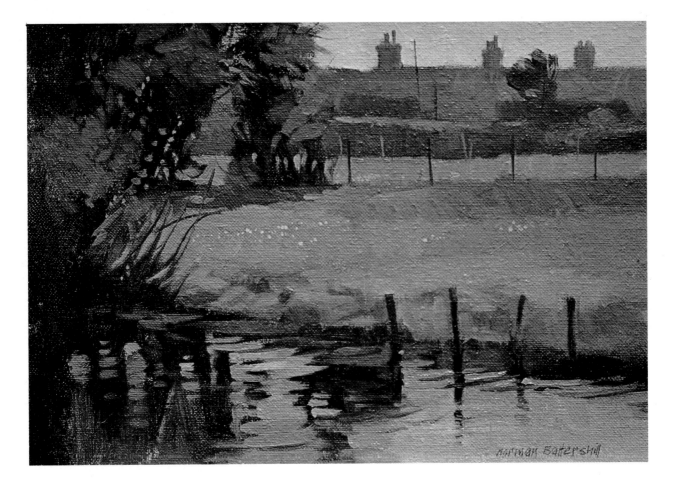

Plate 10 *Summer morning*. Oil on canvas mounted on hardboard
14 × 10 in./356 × 254 mm. I painted this scene outdoors at eight o'clock
on a summer morning. When I began painting the light was soft and
pale but later it became bright and made everything sharper in
contrast. However, I kept to my original intention of soft early morning
light. The first consideration was tone value, for that determined the
source of light and its effect. Again, the wind constantly changed the
pattern of reflections, so when this happened I carried on painting other
parts of the picture until the patterns became simplified again. I had to
be careful, however, not to let the reflections become too assertive,
otherwise all the interest would have remained in the lower part of the
picture. The red-roofed sheds are useful to create a further plane of
recession, and studying the subject now I see that there is a strong
rhythm between the posts in the water, fence, poles and chimney pots.
This again aids recession.
Much of the underpainting to the left has been retained, giving
transparency to shadows.

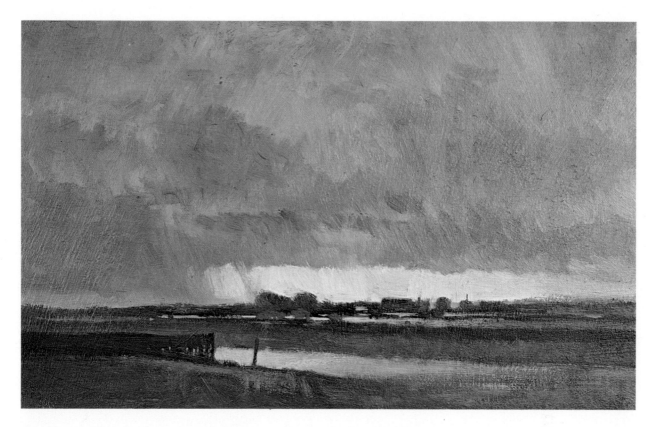

Plate 11 *Coming rain*. Alkyds on hardboard 18 × 11 in./457 × 279 mm.
The scene is imaginary but I worked it out in sketch form before I
began to paint.
A low horizon gives emphasis to the sky and the brooding storm.
The colours used are ultramarine, yellow ochre, cadmium red, cobalt
blue and titanium white. For the flash of distant green I mixed cadmium
yellow with cobalt blue and lots of white.

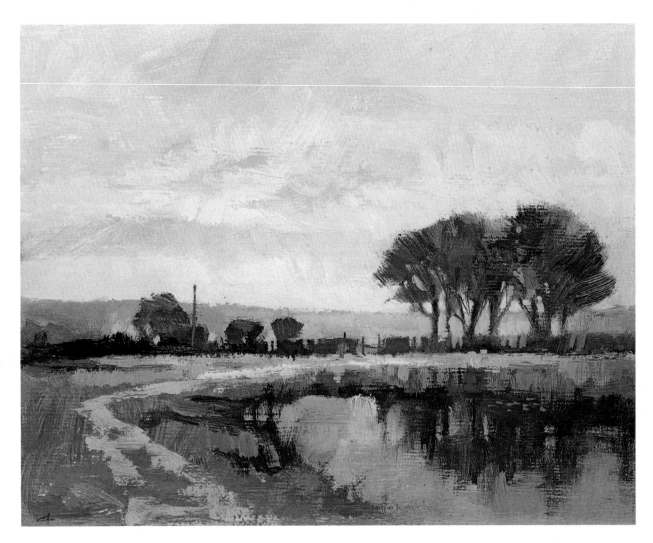

Plate 12 *Sussex pond.* Oil on oil colour paper 10 × 8 in./254 × 203 mm.

5 Painting clouds and skies

Think about Constable's words, 'The sky is the source of light and governs everything.' Learning to observe the sky means something more than just watching the clouds go by. You must make careful comparisons of the tone values of sky, clouds and landscape: they are all closely related.

Before beginning to paint the sky determine what colours you propose to use and set them all out on the palette. Colours should always be analysed before the start of a painting. Don't take the phrase 'sky blue' too literally. The sky and clouds have transparency even on the stormiest days. Light is always present. And both colour and tone are modified by aerial perspective. Blue sky is much deeper directly above, becoming paler towards the horizon: the gradation may be from ultramarine to cerulean blue with a touch of red or yellow; it may perhaps be a predominant cobalt blue or pale prussian, even green. Ultramarine is a useful colour for skies: it is warm and less assertive than prussian blue. Harmony will benefit if you mix a little sky colour with the landscape colours, and adding a touch of colour from the clouds into the sky will also suggest relationship and increase harmony.

Paper or canvas with a preparatory tint will help to give tonal unity and harmony. I sometimes prime my board or canvas with pale grey. Or try laying in a thin stain of yel-

low ochre diluted with turpentine and painting the sky and clouds into it while it is still wet. Constable stained some of his canvases and boards with burnt sienna or burnt umber, dark stains which give richness and warmth.

Freedom of approach is very important in painting skies. A vigorous and broad lay-in will suggest cloud shapes and effects of light. Develop accidental areas to advantage. Begin your sky with thin colour and retain some of the underpainting in the final painting. The translucent effect gives depth and light to clouds and sky. Start a cloudy sky with darker colours first, leaving a grey ground tone to represent the lighter parts – painting thinly with dark transparent colours will help to capture the feeling of luminous light.

The landscape painter's interest in clouds is not that of the meteorologist, but he nevertheless needs to have some idea of the physics of cloud formation. A cloud can be defined as a form of condensation in the air at a high altitude. Water vapour is always present in the atmosphere and is caused mainly by evaporation from the surface of the sea. To a lesser degree it also emanates from moist land surfaces. This water vapour is water in a gaseous state and is invisible. If air is cooled to a temperature below the dew point, the excess water vapour is condensed from gas into a liquid state of visible water droplets, which appear as cloud or fog.

Cloud forms reflect the physical processes which are constantly taking place in the atmosphere. They are classified according to altitude and shape. There are ten major types of cloud divided into three groups according to altitude, all the names of the divisions being based on four Latin words:

Cirrus, fringe or thread
Cumulus, heap
Stratus, layer
Nimbus, rain

High: 20,000–40,000 ft (6,000–12,000 m)

Cirrus: commonly known as mares' tails
Cirrocumulus: cloudlets often in ripples or lines, commonly known as a mackerel sky

PAINTING CLOUDS AND SKIES

Cirrostratus: a thin white layer often giving a halo to the sun or moon

Medium: 7000–20,000 ft (2000–6000 m)

Altocumulus: thin flakes or flattened globular shapes, sometimes at different levels

Altostratus: featureless layers more or less grey in colour

Low: up to 7000 ft (2000 m)

Stratocumulus: soft grey globular masses often arranged in a uniform pattern

Stratus: the layer of cloud just above ground level, resembling a fog

Nimbostratus: dense and featureless layer from which continuous rain is falling

Cumulus: thick, dome-shaped clouds with cauliflower tops and a horizontal base

Cumulonimbus: great masses of tower-like vertical clouds; the tops spread out to an anvil shape

The type of the cloud and its precipitation is dependent on the upward movement of air caused by variations in air density which form horizontal differences in air pressure; and the character of clouds is constantly being re-sculpted. Drawing or painting a cloud study direct from nature can be no more than an attempt to capture the character and atmosphere of wonderful shapes which alter in a manner as fickle as the light which illuminates them. Your first attempts are likely to be timid and uncertain, but the constantly changing shapes will quicken your hand and eye. I generally try to get the character of the clouds as a whole, then if the formation has changed very little I can work on a section in detail. I am however always prepared to abandon a drawing and start another if a more interesting effect occurs.

Clouds are constantly moving against a vast dome of space. Try to capture some of this feeling in your brushwork.

A project study of line drawings, tonal drawings and colour studies of clouds can prove very rewarding. And make analyses of cloud colours. Write them down, mark-

Six cloud studies. 6B pencil on paper 7 × 5 in./178 × 127 mm.
I drew these cloud studies from one spot, turning in different directions, starting at 9 a.m. and finishing about one hour later. Although at times the rain clouds were very dark, the landscape was always darkest overall.
Before I began to draw I selected a part of the cloud formation. Once I had started I extended the area gradually.
The column of clouds on the left built up quickly, and I half expected the top to be flattened off into an exciting anvil shape. But the winds broke up the cloud formation and scattered it over the sky.

④ 13 July 9.30am

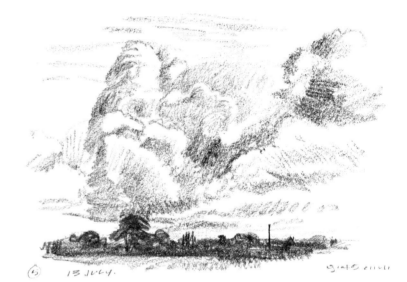

⑤ 13 July 9.45am

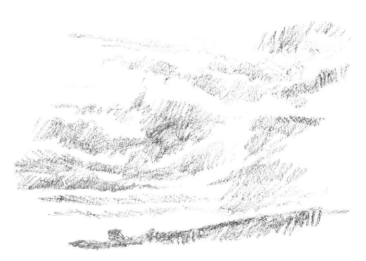

⑥ 13 July 10am

PAINTING CLOUDS AND SKIES

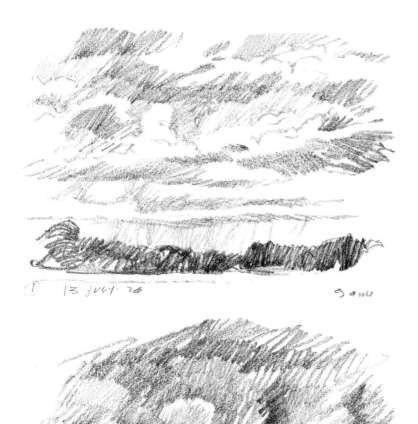

① 13 July 76 9 a.m.

② 13 July 9·10 a.m.

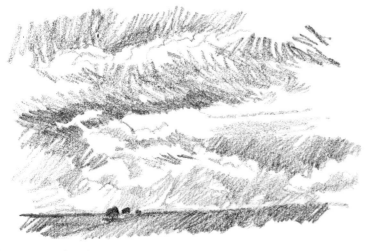

③ 13 July 9·20 a.m.

Demonstration: cloud painting

Before I begin painting I have a firm idea of the effect of light I want, and also the overall tone value. In this case I decide to make the landscape fairly dark to emphasize the light in the sky. The ground is given a stain of neutral colour to reduce its whiteness. I then sweep in the main structure of the composition with a thin mix of burnt umber and ultramarine. At this stage I am only concerned with the principal pattern which is the horizon line and curve of the river.

I lay in to the sky a darker tone of thin colour mixed from ultramarine and burnt sienna with some cadmium red and a little white. I am working the paint wet in wet here and taking care not to get it muddy. I am concerned with establishing a tone value to the whole area. The fields are roughed in with ultramarine and yellow ochre. Preliminary drawing is retained as much as possible.

Tone between sky and landscape becomes more distinct. I am beginning to introduce the effect of light I want. Over the wet colour of the distant hills I paint in a paler colour mixed from cadmium red, ultramarine, yellow ochre and white. The river is a blue-green colour.

The trees are added and recession begins to appear. Now I indicate where the accents are to be: cadmium green and white for the fields, yellow ochre and white for the light on the clouds.

The painting is nearly complete. A sharp line to the hills silhouettes them against the sky. I now paint cloud forms and recession so the eye travels into the picture and away over the horizon. The clouds have softened edges but the landscape is fairly defined.

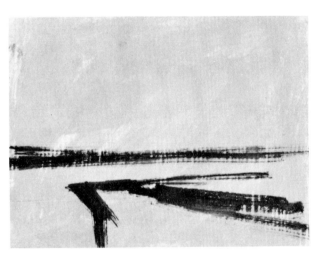

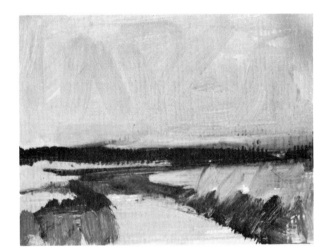

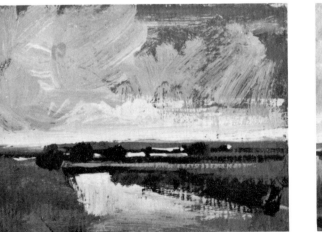

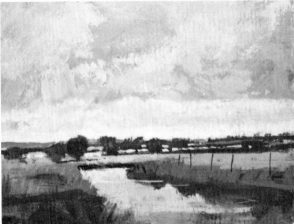

PAINTING CLOUDS AND SKIES

king the date, time and weather conditions and keep the notes for reference. For cloud studies it is more convenient to use a medium capable of expressing line as well as mass: I use charcoal, conté and oil pastel, and for smaller sketches a soft pencil. Use a cheap cartridge paper with a pleasant creamy colour. 18 × 12 in. (457 × 305 mm) is a good size. I also use sketchbooks of about 5 × 4 in. (127 × 102 mm) and upwards.

The following is a useful guide for the beginner in mixing greys for clouds:

Black + white + yellow ochre
Black + white + burnt umber
Black + white + cadmium red
Black + white + ultramarine/cobalt/prussian blue/etc.
Black + white + raw sienna

Sussex Downs. Acrylic on hardboard 24 × 18 in./610 × 457 mm. This scene is not many miles from my studio and a good place for painting. It has distance and a wonderful feeling of space.
I laid in the general tone of the landscape and sky to determine contrast and atmosphere. An overcast sky decided the light on the landscape and gave the opportunity to have the fields quite dark in comparison. The strip of sunlight in the distance emphasizes recession and flatness. It is seldom possible to achieve correct tone values first time; it usually necessitates constant adjustment. Here I repeatedly adjusted the tone and colour of the distant hills before I arrived at the recession I wanted.
I think the tone of the shrub on the left is a bit too dark.

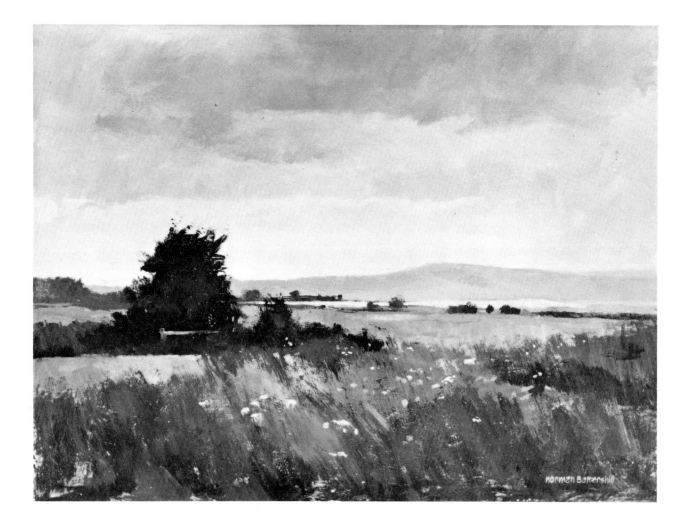

Put white on the palette first and add touches of black until the right tone of grey is achieved, then add touches of colour to turn the negative grey into a subtle grey colour.

Other mixes for clouds are:

White + cerulean blue + orange
White + burnt umber
White + burnt umber + ultramarine
White + raw sienna + cadmium red
White + cadmium red + yellow ochre
White + cobalt blue + burnt sienna
White + cerulean blue + raw sienna
White + cobalt blue + yellow ochre

Attempting to capture the brightness of clouds by the over-use of white will produce not an effect of transparent light but an opaque layer of paint. Transparency and depth can be achieved by various methods. One way is by glazing or scumbling over the dry colour. The glaze may consist of white, grey, yellow ochre, burnt umber, pink or blue, depending upon the degree of warmth or coolness required. For the oil painter wiping out transparent areas with a rag can produce a subtle effect. The pastel painter is constantly reminded of tone value because he works on a coloured ground, normally of medium grey. The water-colourist has the advantage of applying coloured washes to a white textured ground, at once achieving transparency.

If you are confused by the subtle tones of clouds, half close your eyes and the principal tones will be more easily definable.

Clouds of bold shape require careful placing in a picture. They must be governed by the principles of composition, and unless you are emphasizing the sky it is as well not to create a dominant cloud shape or the composition will be unbalanced. Cumulus clouds in particular demand careful placing because of their large and bulbous form.

As an aid to understanding the significance of cloud shapes in the design of a picture, make some simple pencil drawings of clouds in a landscape. Consider the importance of mass in relation to your picture area and the type of

atmosphere you wish to create. Horizontal streaky clouds in a flat grey sky suggest stillness. Banked cumulus clouds are full of movement and light. By the use of diminishing shapes a sense of recession is achieved. Softening and blending the underside of a cloud will also suggest roundness and recession. Clouds appear closer together and greyer the nearer they become to the horizon.

Directly you feel your sky painting is becoming at all fussy or overworked leave it alone. Remember, the time to consider whether your painting is complete is at the halfway stage. Neither sky nor landscape should be overworked to the detriment of the other.

If you are painting in oils and the sky part becomes overworked, wipe it out with a clean soft rag moistened with turpentine. Alternatively a painting knife can be used to remove the paint, but a rag will produce a more interesting and atmospheric effect. The advantage of wiping out is the transparency, controlled by the amount of paint removed by the rag. Firm and repeated wiping out will remove the paint down to the canvas, creating highlights and halftone effects.

You can even create a picture entirely by rag wiping. First paint two bands of dark colour on the canvas. For the top one mix ultramarine, burnt umber and a little white, for the lower band use green mixed from ultramarine and cadmium yellow plus white. From the top band wipe out cloud and tree shapes and from the lower, field shapes. This can be a very useful and stimulating exercise, particularly if your painting is getting muddy and lacking in atmosphere. It works better on canvas than on board because the canvas grain gives a more interesting effect. The watercolourist can use a similar technique, but to a more limited extent, as too much washing out destroys the paper surface.

Whatever your technique painting sky and clouds should always be completed in one effort. Trying to match a colour afterwards invariably shows.

6 Painting atmospheric effects

Sunshine and shade

Sunshine on the landscape is not the easiest of subjects to paint. Tone, even more than colour, needs careful balance, or else your painting will lack harmony and atmosphere and appear too bright. Keep the tones of light and shade flat and crisp. To achieve tonal harmony it may be necessary to lower the tonal key by several degrees. If you prefer to paint at the top of the scale then all the colours should be within that tonal range for harmony. It is not necessary to make shadows dark and heavy and use light colours loaded with white pigment in order to express brilliance. Stain your canvas or board with diluted pale yellow ochre: this reduces the glare of white priming and gives a basis to work on.

Shadows on a sunny day contain light from the sky and surrounding objects. Although they are cool in appearance they also contain warm colours, relating the shadow to sunny areas: yellow ochre or cadmium red mixed with ultramarine or cobalt blue will add warmth. Moreover, even on a cloudless day shadows are affected by atmosphere and lose intensity with recession.

A bright sunny day simplifies tone by dividing it into light and dark. Trees in the middle distance for example may be seen in terms of light on one side and shadow on

1976. June 13 · 12·45 pm

the other. Half closing your eyes will help you to define contrasts more easily. Be careful not to make tree shadows too solid and dark; there is certain to be a lot of blue in the deepest parts. Try using prussian blue and yellow ochre or raw sienna.

Cast shadows have well-defined outlines and patterns of light and shade, and if you paint them as you see them the edges look too monotonous. Soften and blend the outline here and there to give interest and atmosphere. In particular try not to define too sharply shadows and light towards the outer edges of your painting, this is distracting and prevents interest moving into the picture. Painting round a shadow with a light colour can create a much more interesting effect than painting the shadow over a light colour.

Work out in sketch form the main areas of contrast before beginning to paint. Patterns of light and shade are governed by the principles of perspective and composition just as much as the rest of your painting.

Horizontal flat surfaces need not be painted in horizontal strokes; it will give vigour and interest to the paint surface if you break up the surface with vertical and diagonal brushmarks. Note that vertical surfaces in shadow are warmer than horizontal shadows, as the colour of the sky

Summer in the fields. Charcoal on board 8 × 5 in./203 × 127 mm. The sun was almost directly overhead when I did this drawing in the fields near my studio. My main interest was in the mass of foliage and the shadows from a bright sun. To give recession I took tone from the middle distance into the background and kept the foreground very light with the suggested texture of the golden cornfield.

Demonstration: progress of a painting

The support is oil colour paper measuring 10 × 8 in./ 254 × 203 mm; except for the detail in the final stages I used a no. 6 bristle brush; my palette of colours was low in key: yellow ochre, ultramarine, cobalt, burnt sienna, burnt umber, titanium white.

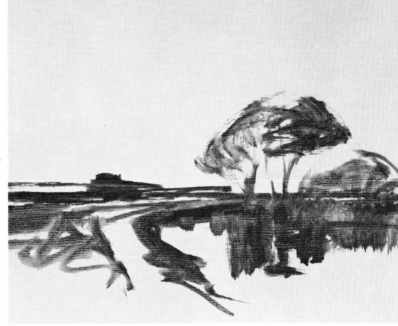

Stage 1. I begin the painting from this small conté sketch measuring 2½ × 2 in./64 × 51 mm. The subject is imaginary. Tones are roughly established first.

Stage 2. Mixing burnt umber and ultramarine I lay-in the main shapes of the composition. The oil colour is diluted with turpentine without any white added.

Stage 3. The overall tone of the landscape is established and general colours laid in. Sometimes I paint the sky in at the half-way stage, but in this case I leave it until last. The painting is thin but I have begun to use white mixed with the colours for the pond. Darks are not overpainted yet.

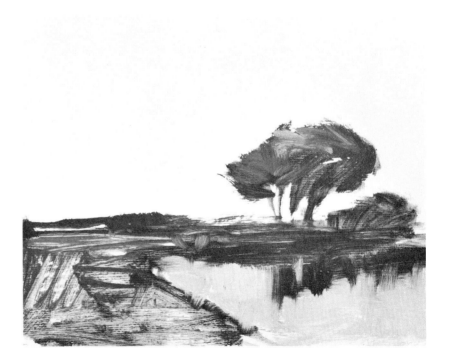

PAINTING ATMOSPHERIC EFFECTS

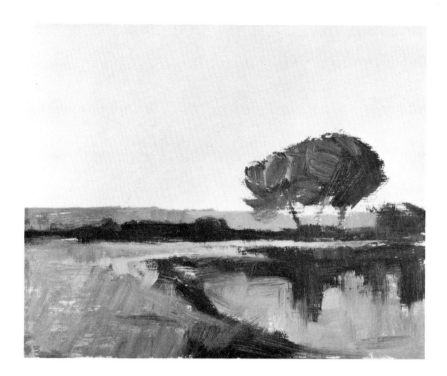

Stage 4. The line of distant hills is now much more positive. Later I shall modify the colour to make it recessive. I use white extensively with the colours to get a solid build-up. I must start thinking about the sky.

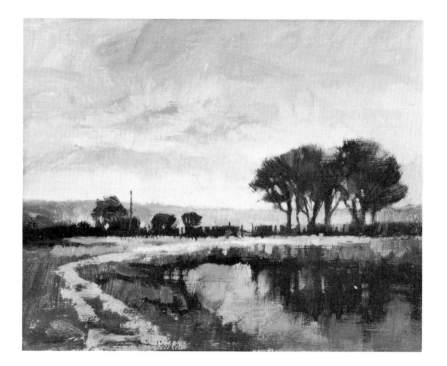

Stage 5. The sky I have decided will be overcast to suit the painting, with soft light on the horizon. This is soon laid in using cobalt blue instead of ultramarine, with additions of burnt umber, yellow ochre and burnt sienna. At this final stage of the painting I tone down the line of hills with cobalt blue, painting wet into wet. I use a smaller brush to add detail to the hedge and trees. The path is put in when the underpainting is fairly dry. A few restrained accents here and there complete the painting. A reproduction of the completed painting appears in colour plate 12.

Demonstration: changing light

The same subject under different light conditions has interesting variations of atmosphere. Subject and composition here are imaginary. It is a good idea to work out an idea for a painting in this way if you have no predetermined thoughts on light and atmosphere. Or a charcoal sketch can help to solve the problems.

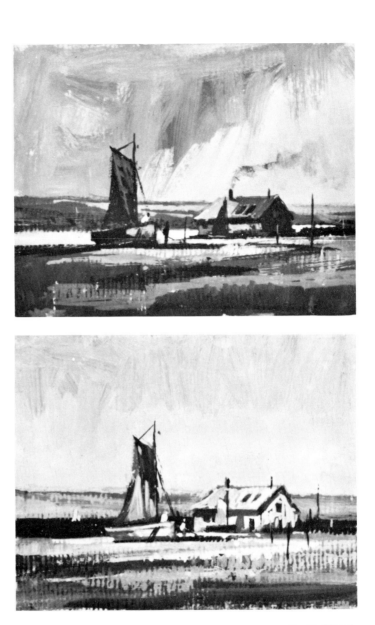

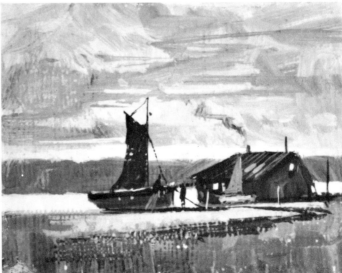

PAINTING ATMOSPHERIC EFFECTS

is more directly reflected into horizontal surfaces.

To unify shadow and sunlit areas try applying a glaze of warm colour over both areas when the painting is absolutely dry. This technique was first introduced by the early oil colour masters and later used by watercolourists as well.

Green in strong sunlight is very bright and this can create particular problems, but applying the green on top of a burnt umber or grey stain and allowing the underlying colour to show through has a modifying effect.

Avoid painting with the sun shining directly on to your canvas. This gives a false value to the colour and your painting will appear very different when you look at it at home.

Grey weather is much easier to paint than strong sunlight because we are able more easily to distinguish tone values without the distraction of assertive colour.

Mist

A misty landscape is a study in tonal contrast of muted colours. The tone values of a misty background are low in contrast and much more controllable than the tones of a bright sunny day.

A thin stain of pale grey over the panel, canvas or paper will help to establish unity throughout the painting. Or another method is to rub over your canvas with a dark grey mixed from ultramarine, burnt umber and white, and while it is still wet lift out the lighter areas with a clean rag dipped in turpentine if you are using oils, or a damp sponge for watercolours. Wipe out gently to begin with so that tones are created by degrees. With practice you will know how much pressure to apply. The pastel painter of course has to rely on the technique of application. A dark brown or dark grey paper can be used for strong foreground silhouettes. A medium grey pastel is rubbed into the background to provide a basic tone. Take care not to rub too much and lose the texture of the paper. The drawback to this technique is the danger of its becoming overworked and smudgy. Alternatively you may prefer to use a medium grey paper and build up the darks using the colour of the paper as a middle tone.

Dawn on the Halifax moors.
Acrylic on hardboard
31 × 27 in./787 × 686 mm.
The rugged moor and the house
in the early morning light set the
theme for my painting developed
from a sketch. The sky was
atmospheric with mist and I
painted it a dusty mauve rising to
pale pink. Orange light from
street lamps suggests recession
around the road going out of
sight. The road slopes steeply but
the house is on a horizontal plane
in perspective.

Whatever your medium and method your main concern must be to avoid a dead grey. Mist and fog are permeated by light. Visibility is determined by density and will have a quality of transparency even with a low degree of light penetration. The light is diffused and emphasizes horizontal and angled surfaces. Try to get this feeling of diffused light into the background and sky area. Even if the source of light is obscured its reflection, on a roof angle or a stretch of water for example, can be quite bright. Moreover, mist is seldom a cool colour. Add a touch of cadmium red or yellow ochre to the grey to warm it.

Placing principal colour and tone in a muted subject requires careful thought. The colours even in the foreground of a misty landscape are not clear but influenced a

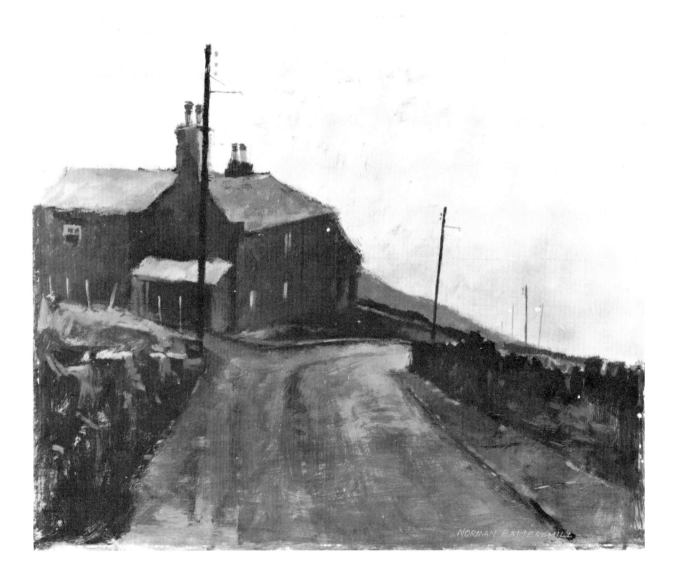

PAINTING ATMOSPHERIC EFFECTS

little by greyness. Your composition will improve if the light is kept in one main area and not scattered in patches of equal importance. Begin your painting with carefully selected basic tones, warmer in the foreground than in the distance. Simplifying the number of tones can be very effective. Begin with four, carefully composed of foreground, middle distance, distance and sky.

I have painted and drawn in fog and remember the mysterious quietness and the way trees appeared and then faded into the background. The tones constantly changed with the varying density of the fog. It is an odd experience, painting outdoors in fog or mist, and a valuable one. Whether your picture is a success does not matter; you will have gained experience in the understanding of tone and the magical quality of light and atmosphere.

Sunsets

When painting such a fleeting moment as a sunset you must work quickly and try not to change your mind and alter things. Spontaneity will disappear as quickly as the effect. Work outwards from the main source of light. Note that the brightest part of the sunset may not be the sun but the clouds immediately above it, and that light pervades all the landscape with warm colour.

Victorian painters depicted sunsets with unashamed romanticism. Their better paintings are good examples of how to control colour and tone, but their enthusiasm has meant that most painters now avoid the subject as a theme because it has become hackneyed. If you tend to think of paintings of sunsets in terms of mediocre work, have a look at Claude Lorraine's marvellous painting *The Embarkation of the Queen of Sheba*. The sunset fills the whole picture with a golden glow.

Storms

The first point to be considered before starting on a storm painting is whether the storm is to be in the middle distance or distance or to cover the whole painting as a main theme.

Storms, like sunsets, were overworked by the Victorians

and are consequently seldom used today as the main theme of a painting. But a storm offers a dramatic subject. Patches of sunlit landscape give valuable contrast of light and dark against the sombre areas of grey cloud. Again, sometimes a rust colour storm cloud will sweep across the landscape completely obliterating it: parts of the distance are revealed and others lost in the deluge, presenting an exciting example of the play of light against dark.

Storm paintings are (for good reason!) mainly created in the studio. My painting *Collapse of the Brighton Chain Pier 1896* is of course an imaginative composition, but it is based on fact. Research into the subject showed the construction of the pier and the manner in which it was likely to have collapsed. It is thought that the gigantic iron chains suspending the promenade between the towers were continuously dragged at by the sea and finally pulled the towers over. Reading an eye-witness account I discovered that the red navigation light at the end of the pier remained until the final collapse. I made the spot of red the focal point of the drama.

Collapse of the Brighton Chain Pier 1896. Oil on hardboard 42 × 29 in./1067 × 737 mm. My reconstruction of the storm which destroyed the elegant Brighton Chain Pier on the night of 4 December 1896 is based on an eye-witness account.
To give an effect of sway towards collapse I placed the platform structures in opposite directions. The sky merged into the sea to create a feeling that the pier is being enveloped by nature's forces. Much of the sky and sea I kept translucent as a contrast against the solidity of the platforms and towers.
The colour scheme is principally grey-green and blue-black.

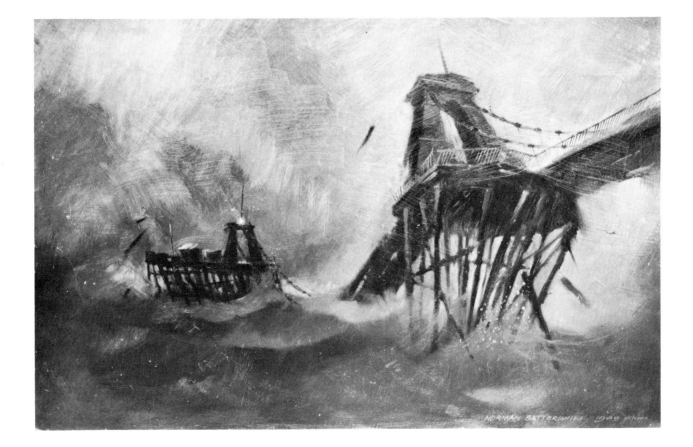

PAINTING ATMOSPHERIC EFFECTS

7 Painting water

Water is a complex subject to paint, reflecting many colours and tones and breaking into fragmented shapes. As if the surface did not present enough problems we also have to consider its depth, the colour of the mud, gravel or sandy bed and the colour of the water itself.

Where to begin? The sky has the greatest influence on the colour of water. Study carefully the tone of the water and its reflections in relation to the sky. You will find that it is invariably darker except for accents. To arrive at a general colour, half close your eyes and look not for the darkest or lightest colour but somewhere in between. This middle tone is what you build on, so it is important to get as near to it as possible. If you make the water too light it will not lie flat but will stand up like a wall. Painted too dark it may look like a hole. Some useful colours for painting the sea are terre verte, prussian blue, yellow ochre, ultramarine, viridian, cerulean blue, cadmium red, burnt umber, titanium white; for streams and rivers burnt umber, ultramarine, yellow ochre, sap green, cadmium red, cerulean blue. Experiment with two or three colours mixed together, then gradually increase the range. Burnt umber and sap green mixed together and well diluted will give a useful colour for the middle tone of a stream or river. Experiment also with raw sienna and ultramarine mixed

Low tide, Newhaven. Oil on hard-board 12 × 10 in./305 × 254 mm. Atmosphere is very much affected by how much detail is left out or simplified. Although this painting has a busy aspect it is not allowed to intrude too much on the overall unity of the composition and atmosphere. Buildings blend into the landscape and are defined by three tones, light, half-tone and dark.

together. If you wish to add white keep it to a minimum; chalky colours do not give the appearance of water.

Having decided on the general tone and colour, paint in quite freely over the whole of the water area. Begin your painting with thin paint and retain some transparency throughout. Acrylic is ideal for transparent underpainting. The pastellist can either make full use of the colour of the pastel paper or else rub in a thin application of colour. The watercolour painter has to plan more carefully. Usually highlights are represented by the paper and painted round. Alternatively, some watercolourists take out highlights with a sharp blade, or lift them out with a wet brush and blotting paper. Turner is reputed to have grown his thumb nail long specifically for scratching out highlights in his watercolours.

PAINTING WATER

Rocks in Cornwall. Oil on canvas
25 × 20 in./635 × 508 mm.
Painted outdoors in a biting
October wind. My recollection
of the weather and atmosphere
is still very strong.
The tide was coming in so I
concentrated on the waves and
the effect of sea running off the
rocks. The rocks were drawn in
with a mix of burnt umber and
ultramarine. Thinned burnt
umber and burnt sienna gave a
middle tone. For deep shadow on
the rocks I used burnt umber and
ultramarine, for the lighter parts
yellow ochre, burnt umber and
white. After roughing in the
rocks I indicated the sky and the
sea. The sea is terre verte, ultra-
marine and yellow ochre with
white, and I also used cobalt blue
for the foam and shadows. The
sky is yellow ochre and ultra-
marine with white. However, I
did not use any white direct from
the tube for accents.

Storm off Brighton. Oil on hard-board 12 × 10 in./305 × 254 mm.
The waves diminish in size with recession and help to give a feeling of distance. The fishing boat gives the scale and also creates an important relationship between the sea and the sky.
The colours used are terre verte, ultramarine, cadmium green, burnt umber and titanium white.

Porthleven. Oil pastel on scrap paper 10 × 7 in./254 × 178 mm.
Even if this drawing never turns into a painting it was fun doing it. I particularly liked the steep angle of the road and the fishermen's chapel embedded in the rocks.

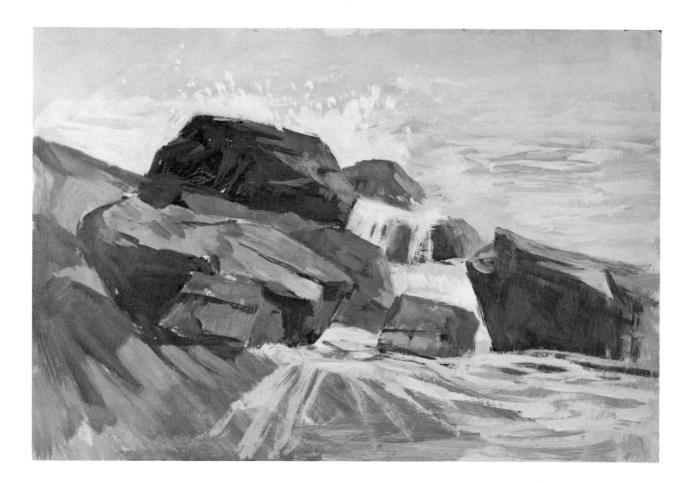

While you are painting be constantly aware of the presence of light on all that you see. Light on the broken surface of water has a different quality from light on still water. The many facets catch the light at different angles.

Paint the reflections of objects at the same time as the objects themselves, remembering that a dark object has a slightly lighter reflection and a light object a darker reflection, and also that the colour of anything reflected in water is influenced by the colour of the water and light. You will see how this works if you stand an object first on a colourless mirror, then on a tinted mirror. The reflection in the colourless mirror will be almost the same colour as the object, in the tinted mirror the reflection will be quite a lot darker. Water has a colour of its own which is mixed with the colour of the reflection. Reflected light in water is seldom white; it usually has a darker tinge of the sky. The closer you look the more colours you will find in reflections. Sort out the main areas first, simplifying as much as possible the colour and pattern of the reflections,

Impact. Oil on hardboard 20 × 16 in./508 × 406 mm. Much of the thin underpainting of burnt umber and burnt sienna remained in the final painting to give texture and transparency to the rocks painted outdoors.

Porthleven. Charcoal on scrap paper 10 × 7 in./254 × 178 mm. I liked this composition because it has plenty of interest without being too fussy in detail. I have not done a painting from it but there are possibilities of developing the sketch into a worthwhile subject.

Overcast sky. (Right) Oil on hardboard 24 × 12 in./ 610 × 305 mm. A studio painting. One of my main interests in landscapes is aerial atmosphere and recession.

The effect I wanted was that of an overcast sky just before rain. The reflections and the colour of the water had to be tonally correct in relation to the sky, otherwise they would appear as separate entities.

The colour scheme is limited, with just an accent of purer hue across the distant fields. My lay-in of the water was translucent with solid colour built up on top of it, but retaining some areas of thin colour in the final painting.

The rain cloud to the right of the picture establishes distance and reinforces the atmosphere.

Weir. (Top right) Acrylic on hardboard 24 × 16 in./ 610 × 406 mm. The contrast of texture between the two levels of moving water gave me an interesting study. Like the surrounding landscape the water is influenced by the light from the sky. I painted the reflections in the still water with blended edges, but in the lower level of moving water the reflections have a more defined edge. The colour scheme is green-grey and rust.

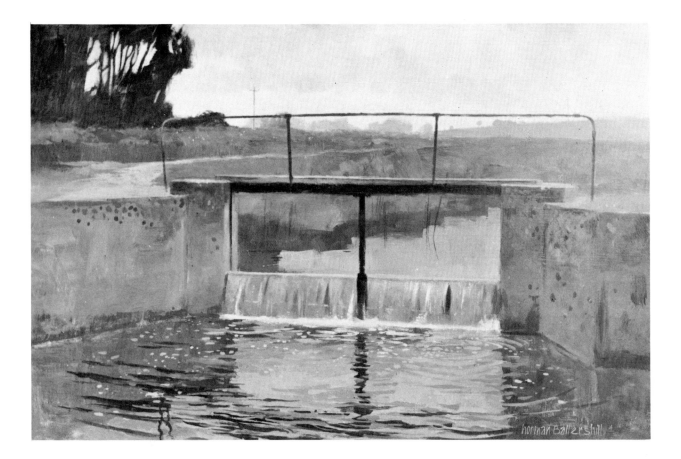

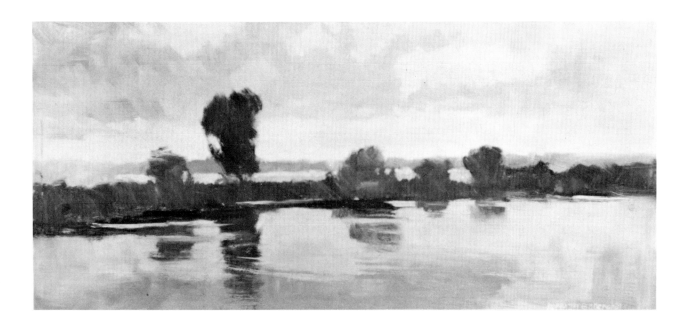

Three stages in the painting of reflections in oils.
I first of all rough in the darks with a mixture of ultramarine and burnt umber.
Next come the middle tones. I mix cadmium yellow with a touch of blue and white for the grass bank and its reflections. I indicate the directional movement of the water.
The final painting has the lightest parts of the reflections added while the paint is wet. The poles are almost vertical and leaning slightly towards me, so the reflections are also almost vertical.

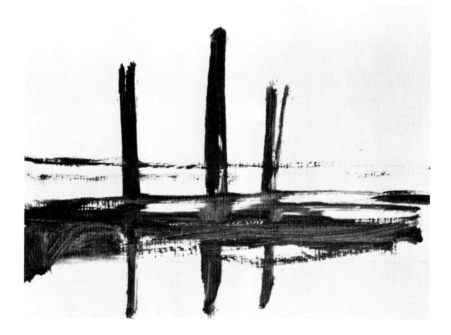

and add detail later. Reflections are a moving maze of pattern, light and colour. It is easy to become confused and lost trying to sort out complex patterns.

Begin your study of reflections by painting still water. When you have tackled that you can move on to the greater complexities of moving water. Moving water follows a general pattern but never repeats itself exactly. Identify the pattern and first of all paint it broadly, forget about the little bits of sparkle until after you have established the reflections. Perspective affects the appearance of

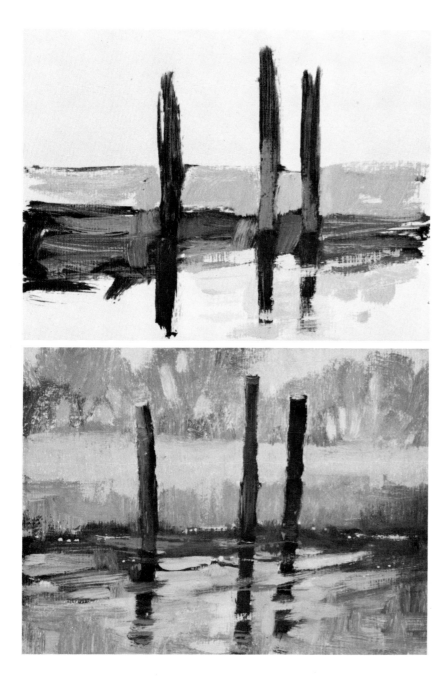

the ripples: like furrows in a ploughed field they appear to become closer together the further they recede. Each ripple picks up part of the reflected subject and visually extends it. Across the elongated reflection there may be parts broken or obliterated by surface disturbance from wind or current. This however is an aid to the artist because a horizontal or slight angle painted across a reflection helps it to lie flat.

Part of a reflection can make an interesting study in itself.

The seashore

The seashore is a fascinating subject, impossible to discuss fully in such a small space. It offers dramatic effects of atmosphere and beautiful studies of light on water.

Selecting part of a seascape as a subject for a painting can be particularly difficult. Using a viewfinder to isolate sections and angles of composition is extremely helpful here.

Your first consideration, as always, is where to place the horizon. If it is high up on the canvas the emphasis will be on rocks and sea; placing it low down emphasizes the sky. If the horizon is out of your picture there must be enough of interest to justify the exclusion.

Patterns are created by sand, rocks, pools and pebbles – note the contrast of texture. Further patterns are added by

Ebb tide. Oil on canvas
30 × 24 in./762 × 610 mm.
A winter seascape painted outdoors. I had to weight my box easel down against the wind. The light was flat and the sky covered with grey cloud. The effect of light on sand and rock pools under such weather conditions is soft and greyed. The distant coastline was in fact dark green, but I changed it to a more atmospheric grey colour to make it recessive.

Much of the preliminary umber stain has been retained to give texture and translucency. Never obliterate entirely the first thin colour lay-in without some thought of whether it might be more effective to retain it.

PAINTING WATER

the flow of water. Look at the effect of light on rocks. If the rock is dry and coarse in texture light is absorbed; when it is wet it glistens like glass, emphasizing the sharp contrasts of plane and edge. Moisten a pebble and the colours become richer, reflecting light brightly. The intensity of the light is influenced by colour not only from the sky but from the colour of the stone itself.

The pools of water left between rocks after the ebb tide offer ideal subjects. The reflections are still and easier to observe than in moving water, and there is often a lovely effect of light in the rock pools. At the other extreme try painting water tumbling among rocks and stones. Reflections are almost non–existent, but this does not make the subject any less interesting – or any easier.

Light on the sea itself is influenced by the surface and colour. Be careful not to make your sea too blue or green unless this colour is to be the feature – grey is always evident in the colour of the sea around the English coast and is an essential part of the colour harmony. Before painting

the foam with pure white, hold a sheet of white paper up to the subject, and you may be surprised to see that pure white is only necessary for accents, if at all.

Waves offer a powerful subject, but it is not easy to capture their form, rhythm and movement. The atmosphere alters the tone and colour of waves. Depending on the weather the pervading light may have a greying effect within quite a short distance of the shore. In the distance waves merge. The horizon likewise often blends into the sky without any visible division.

oct. 75.

Marazion Beach

PAINTING WATER

8 Painting hills, roads and tracks

Hills

Achieving the correct relationship between sunlight and shadow on hills requires care. To see where the light accents should be, wait for the moment when the sun comes through the clouds.

The effect of light on hills produces many subtle colours. A method I often use for painting hills in oils or acrylics is to put in the general colour, which may be grey-green, then while it is still wet blend in a grey-blue. This produces a varied and subtle colour almost impossible to achieve by mixing. The pastellist can overlay his colours to achieve a similar effect. The watercolourist can either blend wet in wet or lay wet top colour on to a dry underpainting, softening the edges.

Hard edges come forward, soft edges help the effect of recession and soft light. Broken or blended edges where the sky meets the hills suggest soft light. If you are painting in oils or acrylics establish the main colour and tone of the hills, then paint the sky into this part while the colours are wet. Blending the sky colour into the colour of the hills has a softening and atmospheric effect. But don't worry if the effect you are after doesn't happen straight away. You will probably have to modify the colour of the hills several times as your painting progresses to get the right effect of

Sussex landscape. Pastel on paper 15 × 12 in./381 × 305 mm. The distant hills give a further plane of recession in this painting. The colour I used for the hills was a middle tone blue with an overlay application of grey pastel. This greying helps to break up the undercolour.

colour and recession. The process of modifying goes on constantly throughout a painting.

For distant hills I often use a colour mix of cadmium red + ultramarine + white, sometimes adding a little yellow ochre. Where the light catches the contours I blend cobalt blue or ultramarine into the main colour. At the base of the hills I blend in softly a pale blue of cobalt or ultramarine. Nothing is defined, only suggested. The blue or grey misty atmosphere created in this way gives an effect of distance. Creating the effect of recession with distant sunlit hills presents more difficulty, but it can be achieved by introducing contrasting shadow into the middle distance.

To establish a relationship between shadow and sunlit

Plate 13 *Shadows*. Oil on hardboard 12 × 7 in./305 × 178 mm.
I painted this outdoors on a summer afternoon in Gloucestershire,
painting direct with very little underpainting and no medium. Working
in the shade I was able to judge tone values more easily. The sunlight
was much brighter than I have painted it: I reduced the tone
considerably to achieve richness. The nearest shadows to the sunlight
were warmer and became predominantly bluer with recession and
coolness.

Plate 14 *Morning mist*. Oil on canvas 27 × 18 in./686 × 457 mm.
A studio painting, based on a drawing. I made no colour notes but
relied on my imagination.
The steep flood banks of the river seen on a misty morning gave me the
theme for this painting. Because the banks had such a dominant weight
and shape I had to soften and blend them to get the atmospheric effect
I wanted. I painted wet in wet to achieve softness and a blending
of edges.

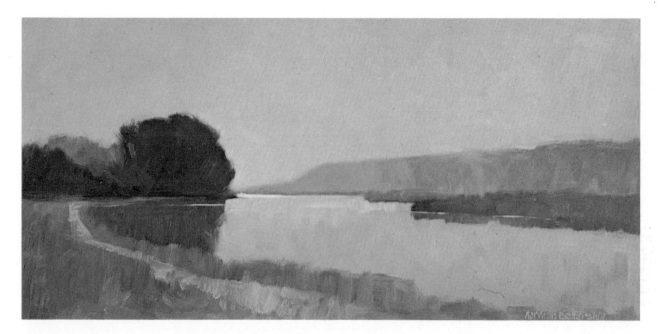

Plate 15 *Path by the river*. Oil on hardboard 25 × 12 in./635 × 305 mm.
A studio painting. Painting in the studio gave me the opportunity to
work the tone values out carefully, without the distractions of
outdoors.
Calm water is the easiest to paint, as reflections are static and more
definable. Note that the dark tree clump has a reflection lighter than
itself, and the sky is lighter than the reflection.

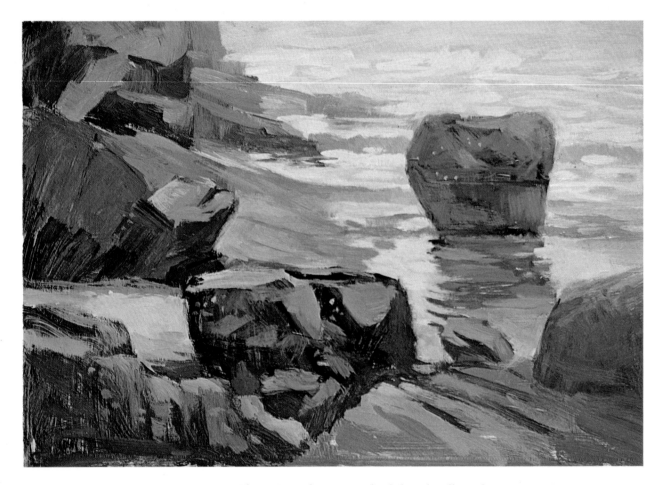

Plate 16 *Rocks – Low tide*. Oil on hardboard 18 × 12 in./457 × 304 mm. Painted outdoors on a cold October morning. The play of light on the many planes is a stimulating exercise in tone and form.

areas, introduce a touch of the sunlit colour into the shadow colour. Shadows on distant hills have blurred and softened edges and are influenced in colour by the quality of light and the colour of the ground they are cast on.

Hills with cultivated areas present interesting patches of colour but unifying the effect of shadow across different colours can cause problems. However, the tone of each area is more important than its colour.

Roads and tracks

A road or track in a landscape adds movement, pattern and interest.

There are many colours in the surface of a road and sometimes it is difficult to know how to begin. In fact the best approach is to forget colour to start with and concentrate on getting the tone right, which is even more important. If the tone is too light the road will appear to stand up like a wall. Make it too dark and it looks like a trench. To create an effect of recession the lightest part should be the furthest away. The surface of a wet road is high in key with reflected light from the sky, and it can shine like a river in the sun.

Wheel marks darken the surface of a road and usually present the deepest tone. Paint this first if you are working

4.
Steyning 7th April 6.pm

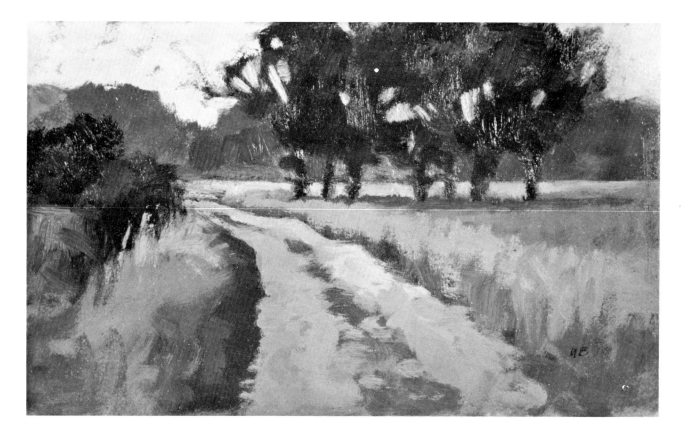

The track. Oil on grey paper
10 × 6 in./254 × 152 mm.
An outdoor sketch. Years ago the
track had a railway line but now
it makes a delightful place for
walking. I have been painting in
the area for a long time and
always find something different.
Changing light constantly alters
the aspects of landscape.

in oils, adding the lighter tones afterwards. Shadows vary
in intensity. And when you are painting shadows across
roads do not assume that the surface is horizontal and flat.
The curvature of most roads, however slight, adds interest
and pattern to shadows and light.

Now carefully observe the colour. A slight sheen to a
road surface reflects a lot of sky colour – an asphalt road
can look quite purple in a certain light. The colours I
commonly use to mix for tarmac are burnt umber, cad-
mium red, ultramarine and yellow ochre. Burnt umber +
ultramarine makes a warm grey.

A country road with grass banks and trees can be a
particularly satisfying subject, especially if there is strong
contrast of light and shade.

Tracks with their undulations and variations of surface
are even more fascinating. The colour of shadow changes
with the colour of the surface: shadow on grass is deeper
than on earth or chalk. When I am painting a track or path
over fields I usually paint the green first and the track after-
wards, so that the lighter colour of the track blends with
the green of the fields or the earth colour. Working light

over dark also helps to achieve a harmony of tone and gives texture to the track.

A chalk track in bright sunlight is very white and generally needs reducing in tone, otherwise it looks too predominant. The colours I mix for a chalk track are ochre and white with a touch of cobalt blue or burnt umber and red. For earth tracks I mix burnt umber or raw sienna and ultramarine with white. Wet ground is darker and richer in tone.

Try not to paint a track too smoothly. Let your brush-marks suggest texture and contour.

Path and trees. Acrylic on hard-board 29 × 12 in./737 × 305 mm. Simplified masses form interesting patterns of light and shade. The grass is deep in tone, relating closely to the dark trees. I established the darkest areas first and then the middle tone, leaving accents until last.

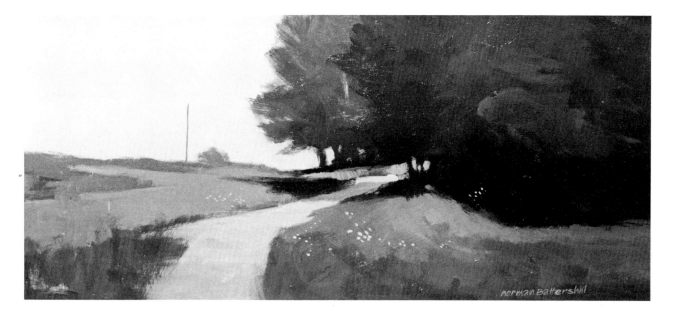

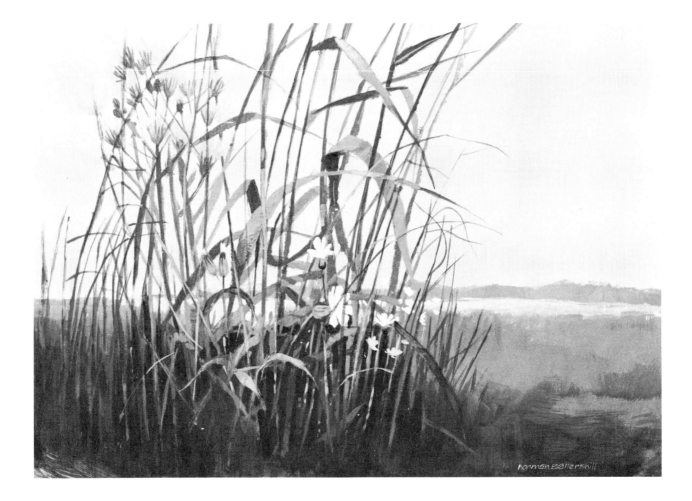

PAINTING HILLS, ROADS AND TRACKS

9 Painting foliage

I have spent many pleasant hours drawing and painting foliage outdoors in all weathers, and enjoying the discipline of close observation. Hedgerows are particularly fascinating with a wealth of interesting shapes and detail. I also collect brambles, grasses, dandelions, celandine, convolvulus, daisies and dog roses to paint in the studio, and in the lobby of my studio I keep an old milk churn filled with the lovely golden colours of wheat, barley, teasels and cow parsley, giant puffballs and slender grasses. But painting foliage indoors is quite different from painting outdoors. It is much preferable to study the effect of natural light on foliage outdoors rather than under artificial conditions.

Leaves are seldom still and with every movement the light on them dances. Bright sunlight on foliage gives density of shadow and also translucency. The upper surface of a leaf absorbs or reflects light, and the underside will appear a brighter green because of light showing through. The surface texture of a leaf determines the amount of light absorbed or reflected. A shiny, smooth leaf has a much higher degree of reflected light than a matt-textured leaf – on a very bright day shiny leaves, like laurel and ivy, glisten. Light on foliage is often lower in key than you think, though. Hold a piece of white paper against the

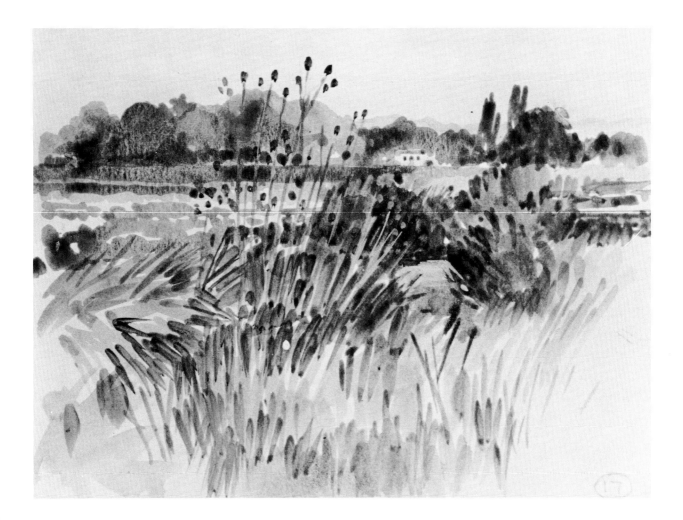

Teasels. Diluted acrylic on watercolour paper 8 × 6 in./ 203 × 152 mm.
An outdoor sketch in acrylic diluted to a watercolour consistency. There was no strong contrast of light and shade but this did not present a problem because my interest was really in the teasels and lush vegetation of reeds and shrubs. I applied the acrylic direct to dry cartridge paper (white drawing paper). The wet in wet technique would have buckled the thin paper and made it uncontrollable.

brightest part to ascertain how far down the scale it is.

I suggest you start by painting a close-up. Select a simple arrangement of about six leaves, or a single stem of a wild flower or weed. Before beginning to paint make drawings in monochrome with oil pastel, pencil, conté, charcoal or chalk pastel. Draw several times larger than actual size. You will then have a better opportunity to appreciate shape and rhythm. Exploring detail in this way is fascinating and rewarding. Become aware of surface textures while you are drawing and look for the inner shapes formed by stem and twig as well as the main outer shapes.

After some exploratory sketches you will be ready to paint. Set up your easel approximately three feet from your subject and use your viewfinder to isolate a particular area. Instead of staining your canvas with an earth colour try blue-green mixed from ultramarine and yellow ochre or terre verte, or prussian blue mixed with yellow ochre.

PAINTING FOLIAGE

Teasels. Acrylic on hardboard
27 × 20 in./686 × 508 mm.
I developed this studio painting
from the acrylic outdoor sketch.
The theme is early morning
haziness with reflections in a
stream and, of course, the teasels.
To achieve the effect of haziness
I deleted the distant house and all
the detail of the foliage. I also
deleted the poplar trees on the
right of my sketch because they
make a direct link with the
teasels, which I did not want.
The light in the stream is impor-
tant because it indicates the
direction of the sun. With the hill
I added a further plane for
atmosphere and recession. The
teasels are contained below the
skyline.
Of course when I made the sketch
I had no preconceived notion of
the studio painting. Keep your
sketches no matter how
uninspiring they may seem to be.

Seed flight. Pastel on grey pastel paper 12 × 10 in./305 × 254 mm. A studio painting from actual plants but with an imaginary background.
I applied most of the background after the dark foreground had been laid in, drawing carefully around each stalk, leaf and flower. The solid shape of the church creates recession from the foreground. The light is soft and diffused from an overcast sky.

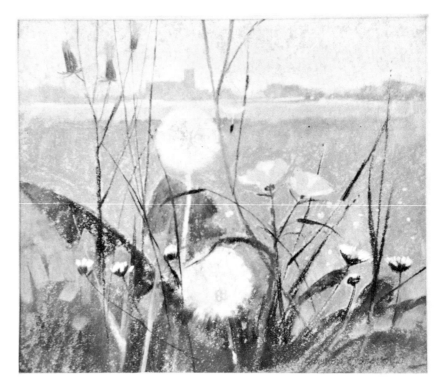

Dandelion. Charcoal pencil on watercolour board 6 × 4½ in./ 152 × 115 mm.
Look at the lovely shapes and rhythms of these dandelions about to form puffballs. Shading is not at all necessary and would detract from the linear quality.

Bramble. Charcoal pencil on watercolour board 7 × 6 in./ 178 × 152 mm.
When you draw a subject like this forget you are drawing 'a leaf' or 'thorns', be aware of form, the outer and inner patterns, texture and rhythms.

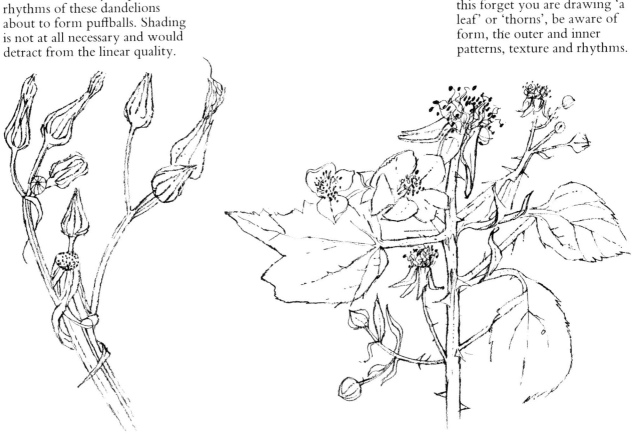

PAINTING FOLIAGE

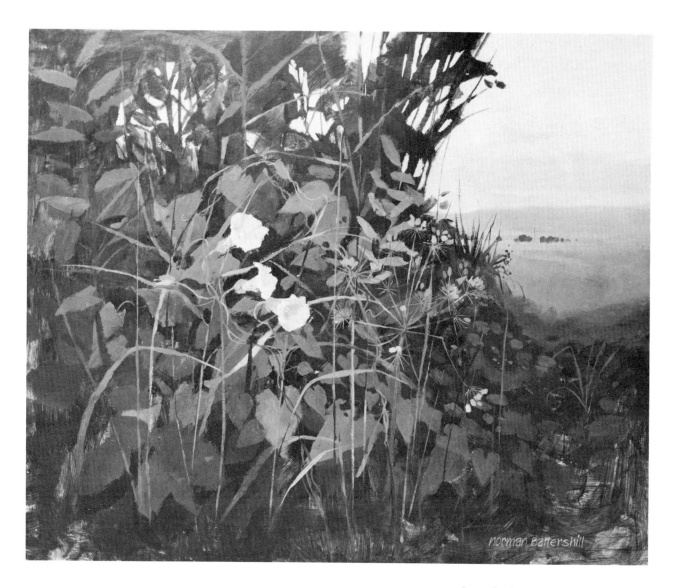

Convolvulus. Acrylic on hard-board 30 × 20 in./762 × 508 mm. A studio painting. Convolvulus flowers do not last very long once they have been picked so I had to work very quickly.

Hedgerows have an extraordinary dimension when looked into closely. I tried to achieve this effect of depth and solidity of growth against distant fields and Downs. I began by staining the whole of the hedgerow area with a thin wash of prussian blue mixed with sap green. This gave me a rich transparent ground to work on.

Acrylics are particularly suitable for paintings like this because they dry quickly, enabling rapid overlay and build-up of colours.

At your first attempt to paint light on foliage you will probably have trouble in mixing the right green. Cadmium green is a lovely sunny colour and takes a lot of white without losing its hue, and a mix of prussian blue and yellow ochre makes a powerful shadow colour. But for greater detail refer to the section on mixing green, page 76. Paint thinly to retain translucency and richness – shadows too have transparent depth. Painting wet into wet will help to capture the feeling of light and transparency.

When you come to painting foliage as part of a landscape composition remember that it must relate to atmosphere and light. Shrubs, trees and grass, although each a different shade of green, are all influenced by the density of light and colour reflected from the sky.

At some time or other you will want to paint flowers and foliage indoors. But place them near a window so as to get the maximum natural light. Artificial light generally has a yellow cast, while daylight is blue.

PAINTING FOLIAGE

10 Painting buildings

Before including buildings in a landscape decide how important they are going to be. Unless you definitely decide you want a different effect, buildings in a landscape should appear part of it, so pay particular attention to harmonizing colours. Modify red brick or tile by adding green or brown. Even on a dry day, roof slates may reflect bright sun in such a high key that the roof appears lighter than the sky, so unless you intend to emphasize the light as an accent it might be necessary to lower the tone. A white painted house in the sunlight has lots of reflected colours. From a distance a white house appears lighter than its surroundings, and strict tonal control has to be exercised to prevent its becoming too pronounced.

The effect of light on buildings can be quite fascinating. Back lighting brings out shapes dramatically and offers plenty of scope for silhouettes against a light sky. Be careful not to make the shadow tone too dark or flat. A few minutes bicycle ride from my studio there is an old barn with its roof supported by weathered posts (see illustration page 148). I had often noticed it and sensed it had a great deal of interest, but it was not until I saw it in strong sunlight that the fascinating contrasts of colour, shade and texture became apparent.

When painting or drawing a subject like this you can

Ditchling, Sussex. Pencil on drawing paper 7 × 5 in./ 178 × 127 mm.
There is an affinity of pattern between the shrubs and trees studded over the Downs and the mellow tile and brick house in the foreground.

Ditchling 13 sept 75

(a)

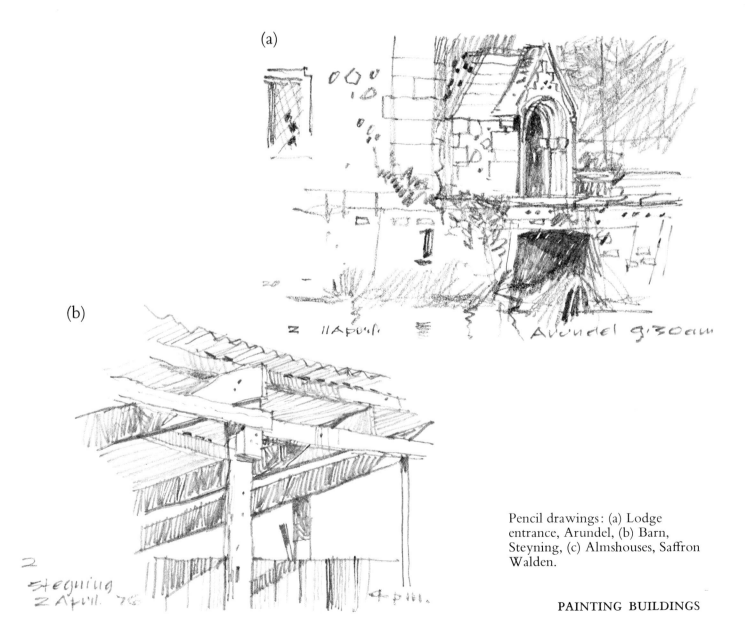

(b)

Steyning
2 April 76

Arundel 9.30am

Pencil drawings: (a) Lodge entrance, Arundel, (b) Barn, Steyning, (c) Almshouses, Saffron Walden.

PAINTING BUILDINGS

begin anywhere and work outwards or begin with the point of main interest. I began with the main post and worked outwards. My principal interest was in the delightful patterns of the shadows cast into the barn. The light changed a lot, so while the sun was behind the clouds I carried on drawing the structure and quickly caught the angles of light and shade when the sun reappeared.

Painting outdoors in bright sunlight is not an easy task, so don't despair if your painting does not turn out as you hoped. Develop another painting from it indoors when you have time to re-consider the problems. It is often more productive to make pencil sketches of the effect of light on buildings than to try to paint a fleeting moment. Monochrome studies of buildings in strong light and shade are invaluable. For my small studies I use a 6B or 8B pencil, or charcoal or pastel. At the time of drawing I have no idea whether it will be of use or not. The important thing is that I am studying light and shade.

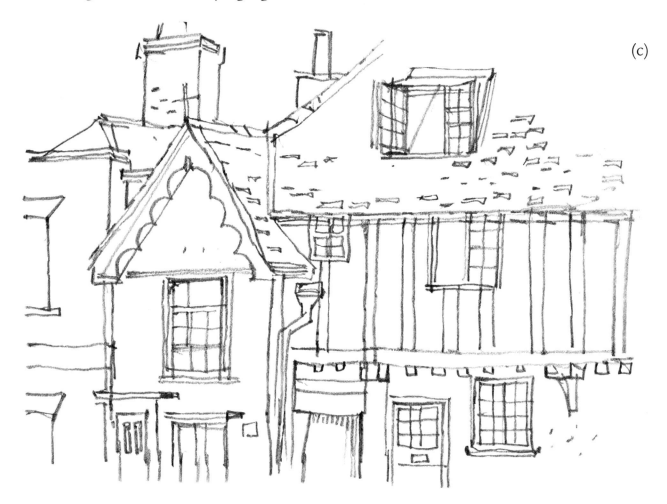

(c)

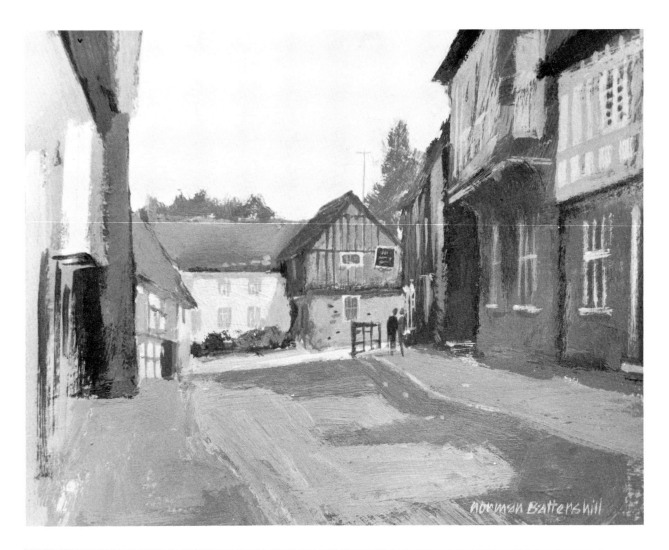

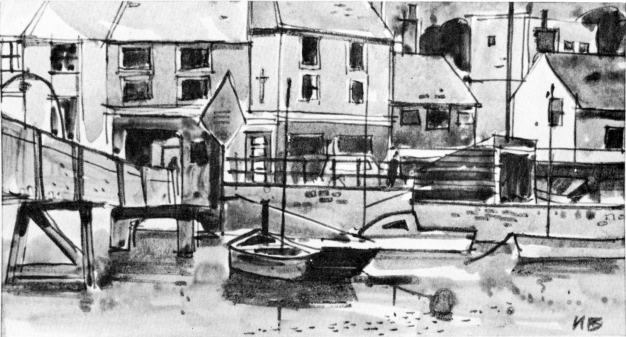

PAINTING BUILDINGS

Church Street, Steyning, Sussex.
Acrylic on hardboard
12 × 10 in./305 × 254 mm.
I painted this acrylic with oil
colour hog hair brushes, first
laying in an opaque under-
painting of burnt sienna and
ultramarine and scumbling lighter
colour on top, to suggest the
texture of the old houses. Detail
is greatly simplified to emphasize
shapes.
My studio is just round the
corner on the right.

Shoreham, Sussex. Felt tip pen
and wash on paper 6 × 3 in./
152 × 76 mm.
A sepia ink felt tip pen was used
for the drawing, and diluted
acrylic applied afterwards. Detail
was minimized to emphasize
shapes. A sketch like this takes
very little time and it is a useful
technique for drawing buildings,
etc. There is no preliminary
drawing but I am careful to place

main features, such as the
diamond-shape notice board, so
that the composition is balanced.

Jetty. Oil on canvas 24 × 16 in./
610 × 406 mm.
The old fishing shed on the quay
is the feature of the painting, and
all the activity centres round it.
I painted in the basic colour and
shape of the reflections at the
same time as the fishing sheds.
The colours I used were cobalt
blue, ultramarine, burnt sienna,
yellow ochre, cadmium red and
titanium white.

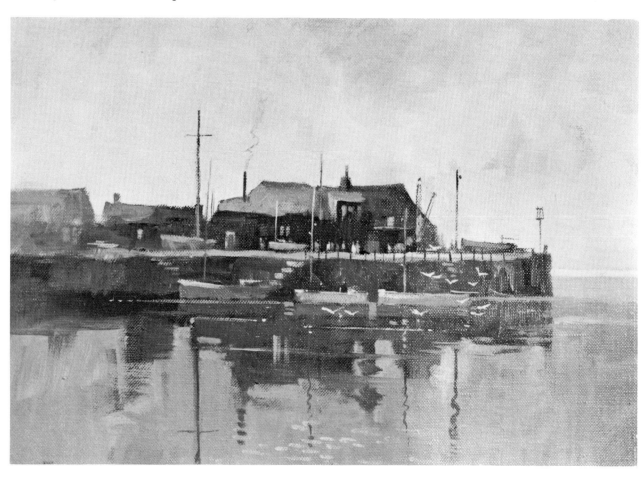

11 Studio painting

Paradoxically enough, you only realize what has been gained from painting outdoors when you come to do a studio painting. Most of the world's greatest landscape paintings were painted in the studio. But the artist depended upon his studies made direct from nature to achieve success.

The advantage of painting a landscape in the studio is that careful thought can be given to getting the effect you want without the distractions of working outdoors. There is more time for careful consideration of construction; colour schemes can be simplified away from the sometimes confusing profusion of colours and tones outdoors. The artist can create the mood he wants for his painting: he may have made a sketch on a sunny day outdoors, but in the studio he can express the subject quite differently if he wishes. Creating a sense of space and atmosphere in a studio painting is exciting, and calls upon the imagination and ability of the artist to the full.

Transferring the effect of light and atmosphere from an outdoor sketch to a studio painting can be tackled in several ways. The spontaneity of a sketch can seldom be re-created in the studio. It has a verve, quality of colour and brushwork not easily repeated. Eugène Boudin wrote, 'Anything painted directly from nature and on the spot has always a force, power, and vivacity of touch that one

cannot find in the studio. . . . Three brushstrokes painted from nature are worth more than two days' work at the easel.' Another problem is that of scale. Much of the value of an outdoor sketch lies in its intimacy. Expanding to a larger picture is rarely successful: a small area of colour enlarged several times is sure to appear quite different in tone and hue: the composition is entirely altered as mass and space become larger; the tree which is effectively suggested by a few brushstrokes in a sketch requires much more detail when the scale is altered. So don't be disappointed if your best outdoor sketch or painting won't enlarge satisfactorily. My own method is generally not to copy an outdoor sketch, but to try to recapture from it something of the atmosphere and light at the particular time. Or else I use the sketch as a basis for an imaginative painting.

An inexperienced painter will probably find colour sketches easier to work from than pencil drawings, but I prefer to work from line or tone drawings made outdoors. A tough discipline perhaps, but it does develop a retentive colour memory. However, tonal values and the divisions into planes can cause difficulties if you have no reference to nature. This can be overcome by making preparatory tonal sketches of the principal masses in charcoal, conté, pencil or pastel.

Another method of composing a studio painting is to put together a number of separate studies done at different times and places. The value of always carrying a sketchbook is for recording not only views but also little pieces of information for possible use. Looking through my sketchbooks I find I have drawings of fishing boats, pulley blocks, masthead lights, beach huts, a trestle bridge, a tractor, sailing boats, sheep, cows, bramble leaves, grasses and much else. Many of these I will probably never have a direct use for, but with every drawing I have learnt something. Whether they ever find their way into a painting or not, the information is there if I want it.

When you are working from a drawing, scaling up is more accurate than depending on the eye. Don't deface your sketches; square up on a clear acetate overlay sheet, using a fine marker pen. Mark out the same number of

Squaring up.

squares, proportionately larger, on the canvas.

Don't get carried away and make your studio painting an unmanageable size – 24 × 20 in. (610 × 508 mm) or 20 × 16 in. (508 × 406 mm) is reasonable for your first attempt.

Before you begin to paint you must have an idea of the kind of atmosphere and light you want to achieve in the picture. Aimless painting is a waste of time, energy and materials.

Painting a landscape in the studio by the *alla prima* method (direct and without any retouching) is not easy, but worth trying if you are hoping to achieve something of the verve and freshness of the outdoor sketch.

STUDIO PAINTING

At the risk of being repetitive I have emphasized the need to work from nature as often as possible. Working indoors from sketches will call upon your imagination and your skills to instil a feeling of space and light into your paintings. What you learn outdoors shows in your studio work. Gain as much experience as you can in the open air and you will find that atmosphere and light will present themselves in your painting much more readily. Do not just paint an effect of light and atmosphere: be totally aware of it. I wish you every success and hope my book will be a helpful contribution towards that aim.

Bibliography

American Artist, New York.

The Artist, London.

Leisure Painter, London.

Constable – paintings, watercolours and drawings. Tate Gallery, London, 1976.

DUNSTAN, Bernard, *Learning to Paint.* Pitman, London and Watson-Guptill, New York, 1970.

GREENE, Daniel E., ed. J. Singer, *Pastel.* Pitman, London and Watson-Guptill, New York, 1974.

GRUPPÉ, Emile A., ed. C. Movalli and J. Lavin, *Gruppé on Painting.* Pitman, London and Watson-Guptill, New York, 1976.

JEAN-AUDRY, Gérard, *Eugène Boudin.* Thames and Hudson, London, 1969 and Newbury Books, Boston, 1975.

MERRIOTT, Jack, ed. E. Savage, *Discovering Watercolour.* Pitman, London and Watson-Guptill, New York, 1973.

PEACOCK, Carlos, *John Constable. The man and his work.* John Baker, London, 1965.

PELLEW, John C., *Acrylic Landscape Painting.* Watson-Guptill, New York, 1968 and Pitman, London, 1976.

RUSKIN, John, *The Elements of Drawing,* Dover, New York, 1971.

SAVAGE, Ernest, *Painting Landscapes in Pastel,* Pitman, London and Watson-Guptill, New York, 1974.

Turner 1775–1851. Tate Gallery, London, 1974.

Turner in the British Museum. British Museum, London, 1975.

Information

Information about painting courses and private tuition in Great Britain can be obtained from *The Artist* and *Artist's Guide*, 7 Carnaby Street, London W1. Correspondence courses in painting are run by the Pitman Correspondence College, Worcester Road, Wimbledon, London SW19.

Similar information for the United States can be found in the Annual Art School Directory issue of *American Artist Magazine*.

Suppliers

General materials and equipment
A. Ludwig and Sons, Ltd, 71 Parkway, London NW1.
E. Ploton Sundries, 273 Archway Road, London N6.
Rowney and Co., Percy Street, London W1.
Winsor and Newton Ltd, Rathbone Place, London W1.

Easels
As above and:
Guys Art Products Ltd, Longbridge Meadow, Cullompton, Devon.

Pastel papers
As above and:
Interprovincial Sales Ltd, BEPA House, Rectory Lane, Edgware, Middlesex.
Italian pastel papers are generally available from art shops.

Pochade
The Mendip Painting Centre, Rickford, Burrington, near Bristol.
For American readers comprehensive mail order catalogs are available from:
Arthur Brown and Bros. Inc., 2 West 46th St., New York, N.Y. 10036.
A.I. Friedman Inc., 25 West 45th St., New York, N.Y. 10036.

Index